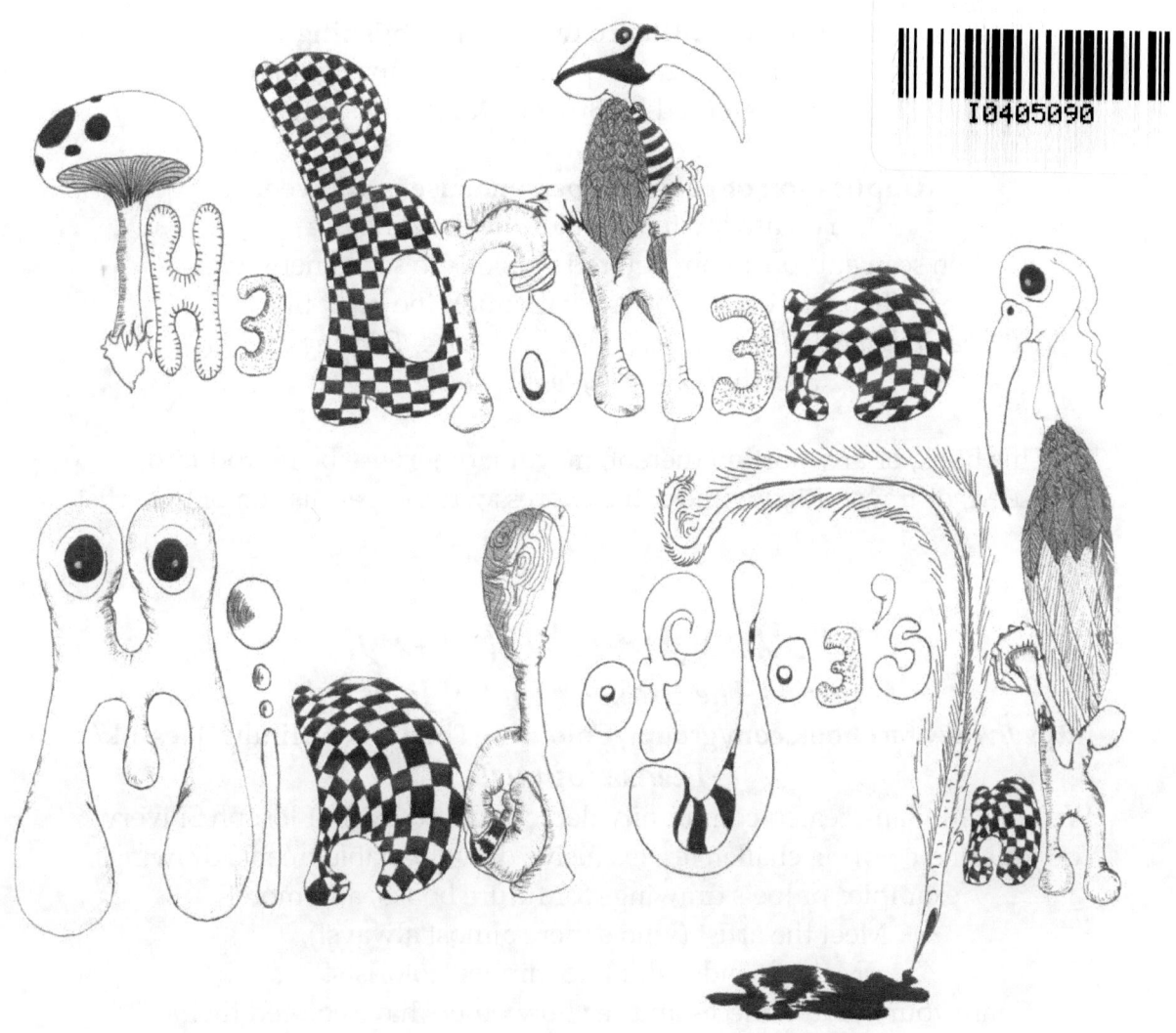

Volume 4

flipping the Bird

Drawings by Joseph Shivery
Stories by Kate (The Quill) Britt

Copyright © 2016 Broken Quill Publishing
All artwork and images are protected by copyright laws.
All rights reserved by Broken Quill Publishing.

Duplication of pages for personal use is allowed.
You are invited to color the drawings,
then scan and post your colored versions to social networks.
When you do so, you must mention the book title
("*The Broken Mind of Joe's Ink*" OR "*Volume 4, Flipping The Bird*")
and the artist (*"by Joseph Shivery"*).

This book, or any portion thereof, may not otherwise be reproduced,
distributed, or transmitted without the express written permission of the artist.

Follow Joseph Shivery!
Coloring The Broken Mind of Joe's Ink
https://www.facebook.com/groups/ColouringTheBrokenMindOfJoesInk/
Please join us!
We are a fun fan-created community dedicated to the art of Joseph Shivery.
You will find coloring challenges, exclusive downloadable freebie drawings,
examples of Joe's drawings for future books, and more.
Meet the artist (who's there almost always!).
Make friends with like-minded colorists!
Share your colored pieces and see how others have colored theirs.
We also share fun, admiration, and applause,
albums of our finished colored pages,
along with personal coloring tips.

All of us at Broken Quill Publishing wish you a colortastic time!
We look forward to seeing your colored masterpieces online.

Purchase individual drawings by Joseph Shivery
https://payhip.com/joesinkearthlinknet

Cover coloring by Kate Britt

This book is about Birds, something that I have always enjoyed drawing. Here are some of my favorites for your coloring enjoyment!

I have always enjoyed working with ink, and started expressing my interest in drawing at about 10 years old. As the years passed, I found sketching and drawing fairly easy. It has always been a favorite hobby, and a great way to relieve stress. In my mid 20s, I began to develop my own art style and have perfected it over the past 30 years. Now, in my mid 50s, I have saved a catalogue of 100s of unique artworks that could be considered surreal—which I would consider to be "The Broken Mind Of Joe's Ink".

I'm a retired Technical Writer, Educator, Copy Editor, and Creative Consultant. A lifetime artisan, I enjoy hopping from craft to art to craft. I discovered Joseph Shivery in 2015 and now I color primarily his drawings!
As a fellow Broken Mind, I'm enjoying creating stories for Joe's drawn characters. Please visit my show-n-tell arts and crafts pages: https://www.pinterest.com/KateMBritt/

Braidie Bird

Braidie is a fraidy-bird,
scared of everything.
He accepts his limitations
so your insults will not sting.

He's almost always happy,
as depicted by his crest—
for when he's sad it's droopy,
but otherwise expressed
as a stand-up swivelling apex!
I know you'll be impressed!

His fear of heights when flying
keeps him soaring along the ground,
where he munches on the bug-world,
while he mostly hops around.

His eggs are round and stripey,
but his nest you'll never see.
He builds it in the tall grass
'neath the Candy-Stripey Tree.

Stories by Kate (The Quill) Britt

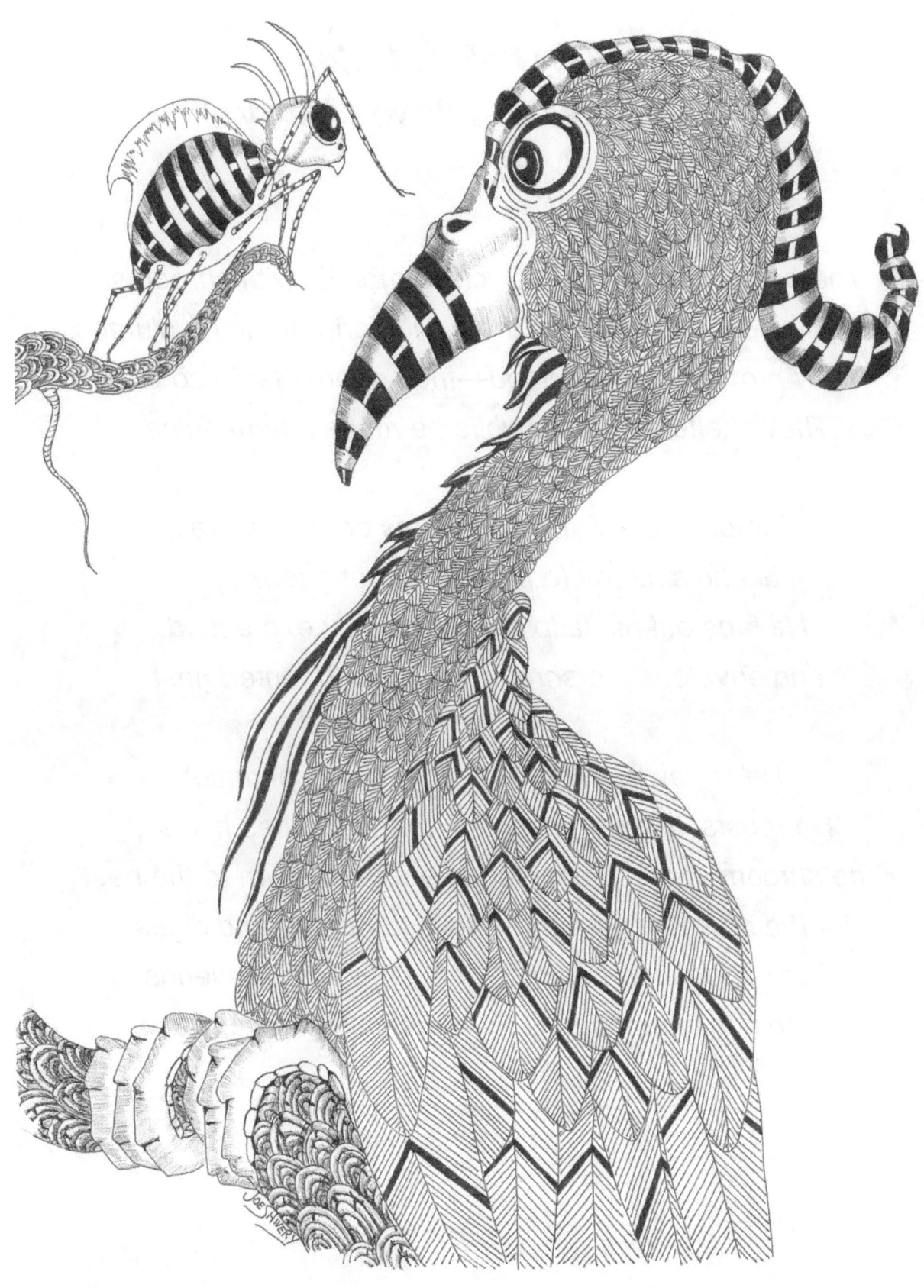

Drawings by Joseph Shivery

Shroom Cock
(Basidiomycetes Pavo Cistatus)

The beauteous Shroom Cock, symbiotic with shrooms.
His tail sweeps and cleans them with long dragging plumes.
They provide him with food—their spores taste so fine.
They shelter his eggs while he makes them shine.

Shroom Cock can't fly with his bounteous tail,
but he's happy to roost, attracting females.
He fans out his tailpiece, its beauty expressed,
and envelops the shrooms—a grand tented nest.

He squawks and he preens, a typical male!
He roosts 'til his eggs hatch, then thrashes his tail.
The shroom spores come loose and rain down to the nest
for the new little Shroom Cocks to munch and digest.
They open their beaks to catch the shroom-seeds,
so rich in nutrition. This meets all their needs.

Stories by Kate (The Quill) Britt

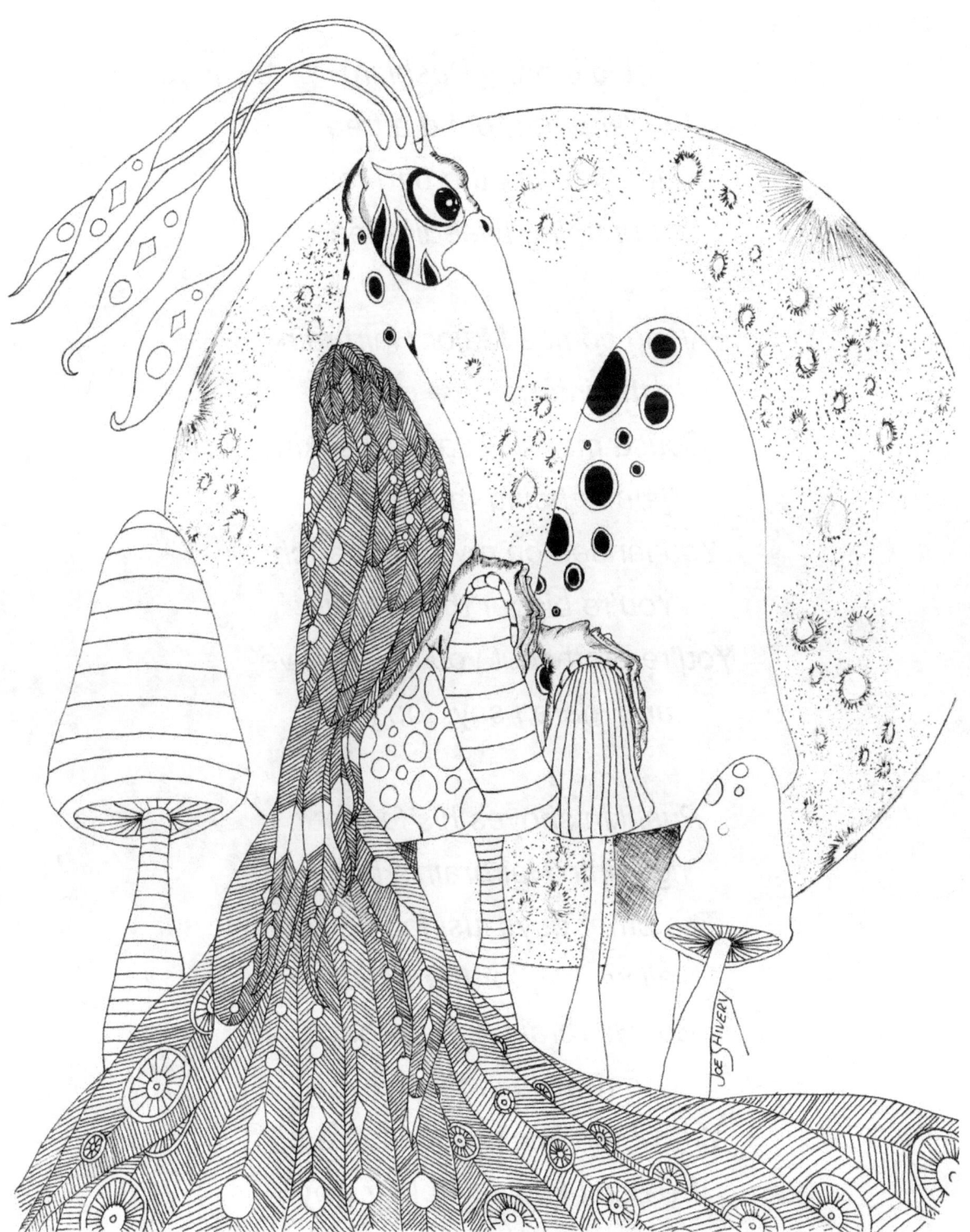

Drawings by Joseph Shivery

When Pushkin Comes to Shove

Little baby Pushkin,
wrapped around a tree,
hangin' with the bird-folk,
humming tweedle-dee.

Along comes Major Hairbrain,
the interruptive dude.
"Scuse me, sir," says Pushkin,
"you're being rather rude.
You landed on my tree branch!
You're bigger than us all.
You're pretty but you're massive,
and, dare I say, too tall."

Pushkin shoves his feet out,
right into Hairbrain's beak.
The other guys just look away,
all waiting for the shriek.
But Hairbrain pushes back,
a twinkle in his eye.
Who'll win this plucky contest?
We don't know who! Or why.

Stories by Kate (The Quill) Britt

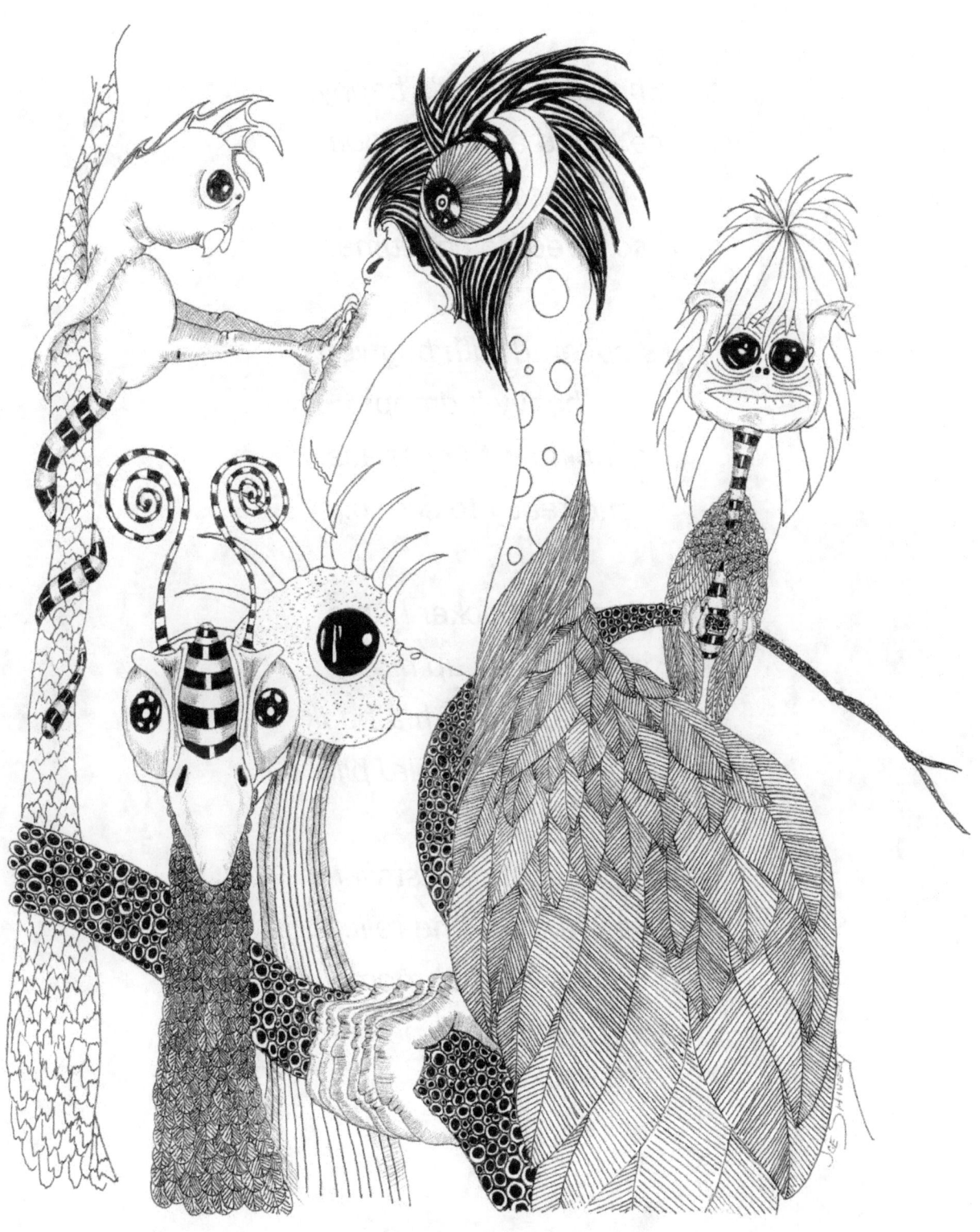

Drawings by Joseph Shivery

Yellow-Necked Shroom Sucker

Shroom Sucker's happy,
he found a new shroom.
It's succulent, juicy,
so sweet to consume.

It's covered with bugwebs,
so heavy it droops,
dripping with ripeness
and ready to scoop.

Shroom Sucker hums
as he drinks up his fill.
He's blessed with a beak
like a hummingbird bill.

His bug-friends just watch
with respect and relief,
that Sucker eats Shroom Juice
but gives insects no grief.

Stories by Kate (The Quill) Britt

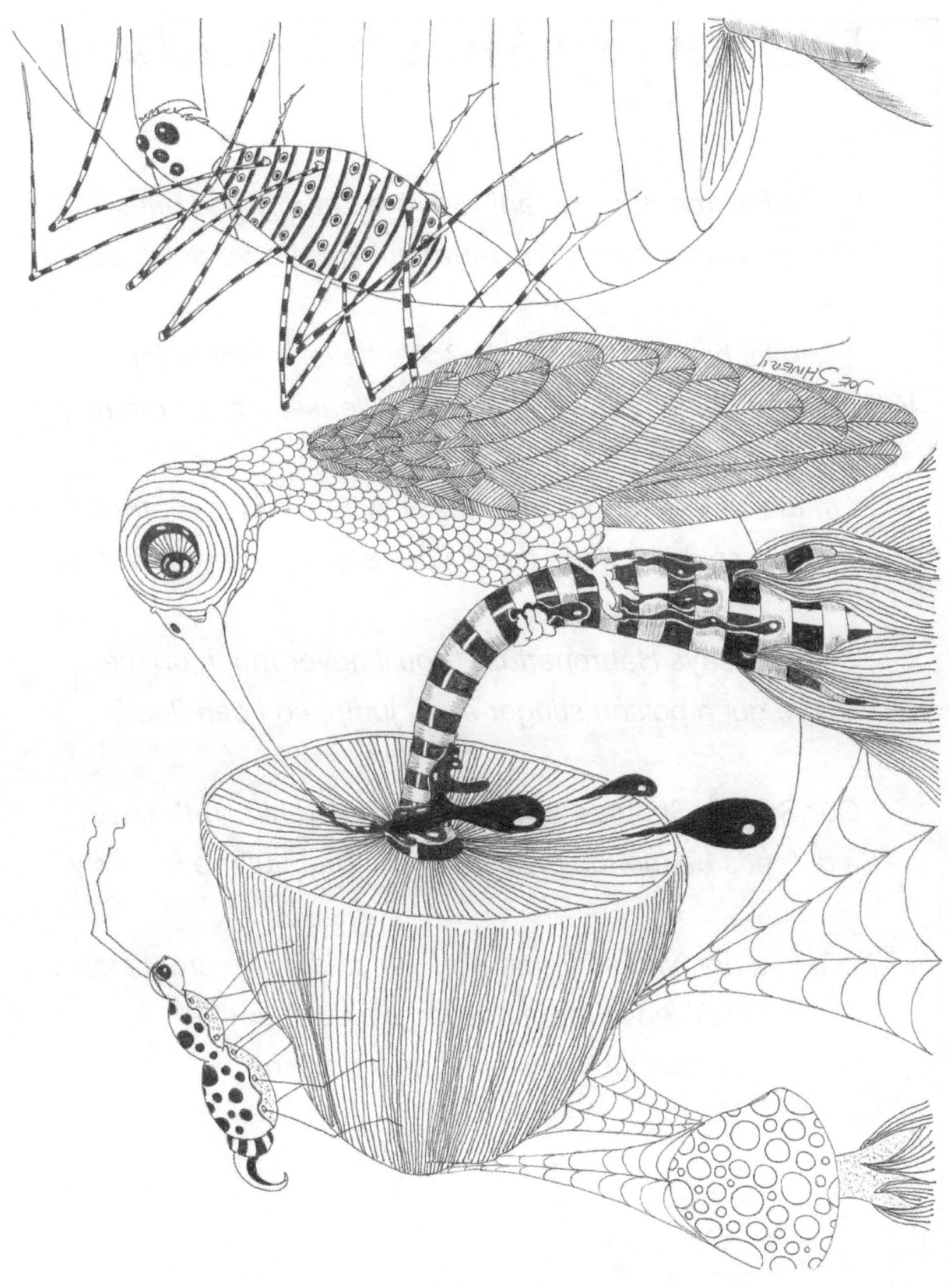

Drawings by Joseph Shivery

The Stripey-Snouted Vulture

"A Habronattus Hallani! So rare I hardly find one!
And here's one sitting on my branch! How're ya doin', son?"

"Hello, bird, do I know you? We haven't met before!
What's your name and who are you? Please, sir, tell me more!"

"I'm the Stripey-Snouted Vulture! Why aren't you afraid?
I munch on spiders all the time! You're going to need first aid."

"Nope," says Habronattus. "You'll never much on me.
I've got a poison stinger and I jump, so I can flee."

Our Stripey-Snouted Vulture just looked him in the eye.
Said, "Let's be friends my little one." That vulture is so sly.

"I'll eat you not, you sting me not," he said as he crept closer.
We'll leave them now so we don't see—
'cuz lunchtime just gets grosser.

Stories by Kate (The Quill) Britt

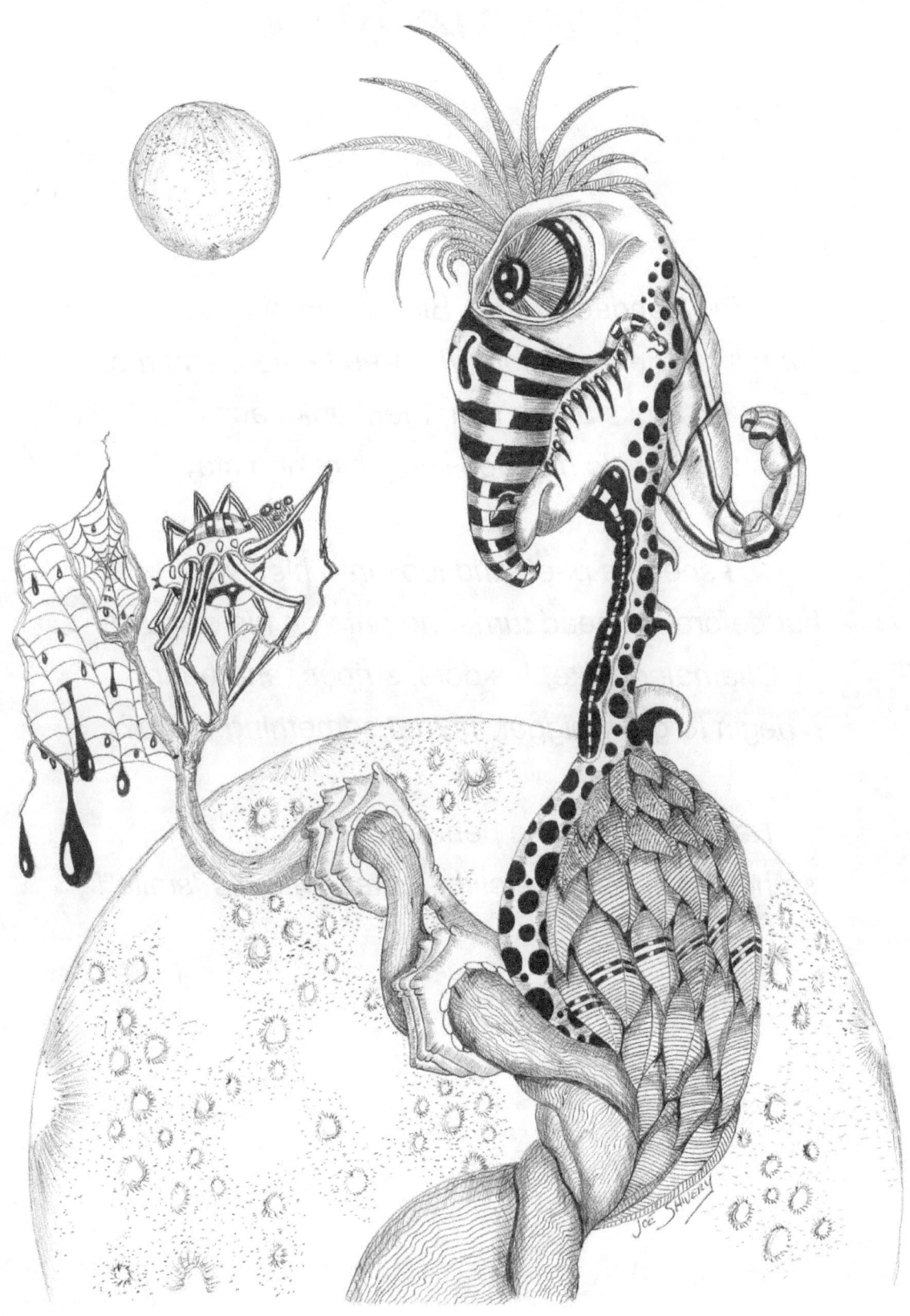

Drawings by Joseph Shivery

Brainie Bird

Big-headed Brainie Bird sits in his tree,
watching the moonlight, the tree leaves, and me.
He looks at me first, then looks away.
I think he's hoping I'll like him and stay.

I sneak a peek and look into his eyes,
but before his head turns, he puts on his disguise.
Chameleon-like, his dots, stripes, and beard
begin to grow bigger. Is that something weird?

He can see I have pencils to color his style,
so he sits there quite still. I'll start with his "smile"!

Stories by Kate (The Quill) Britt

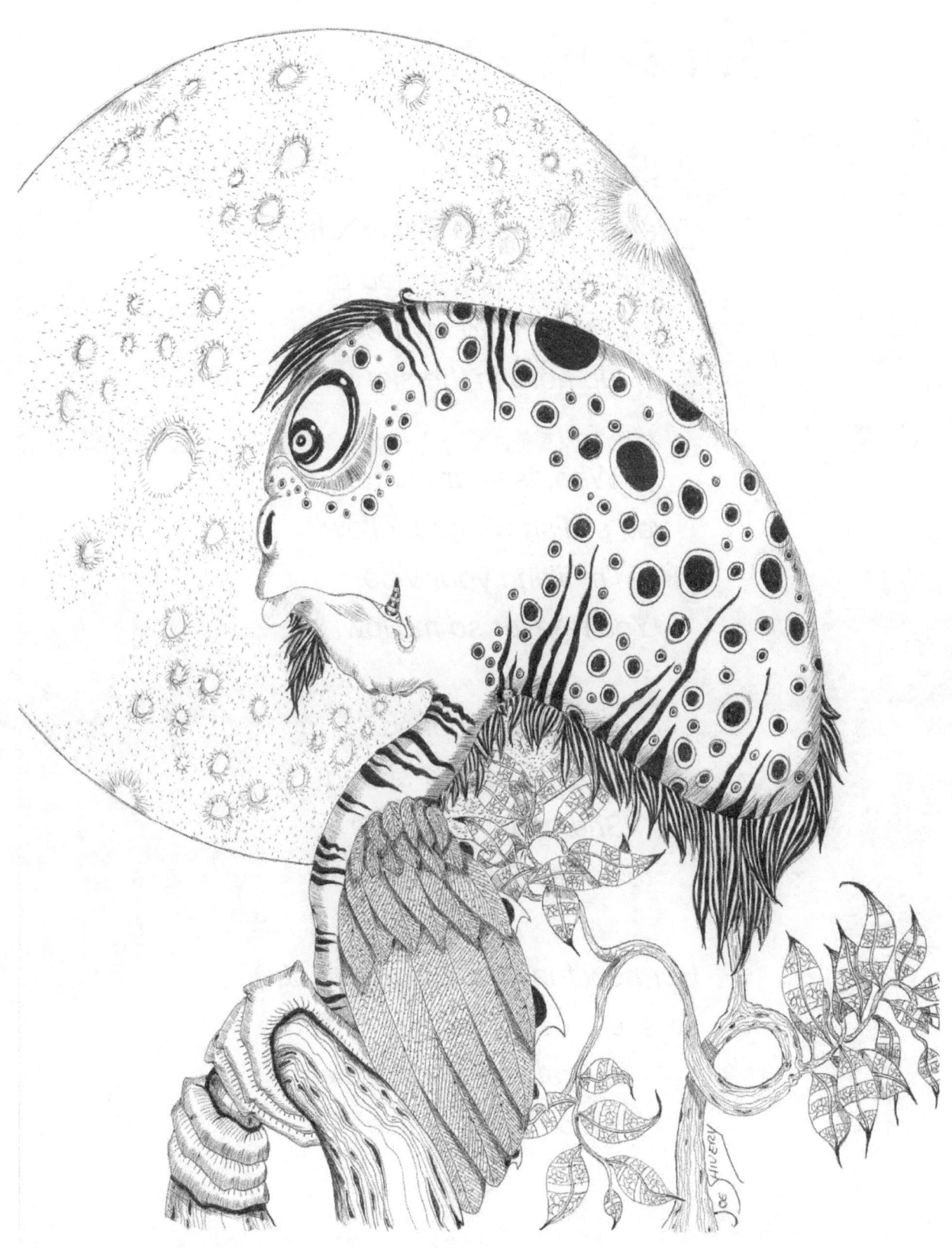

Drawings by Joseph Shivery

Squirmonk's Visitor

"Hey birdie," said Squirmonk,
"I'm glad you dropped by.
Welcome to my tree
up here in the sky.

"What is your name,
you stylish winged fellow?
I'm liking your vibe!
You're ever so mellow!"

Birdie just looked...
well, she actually stared.
She couldn't decide
to be friendly or scared.

Her new friend seemed sweet,
so she preened as she gazed.
"They call me Bandoodie.
It's nice to be praised!"

Stories by Kate (The Quill) Britt

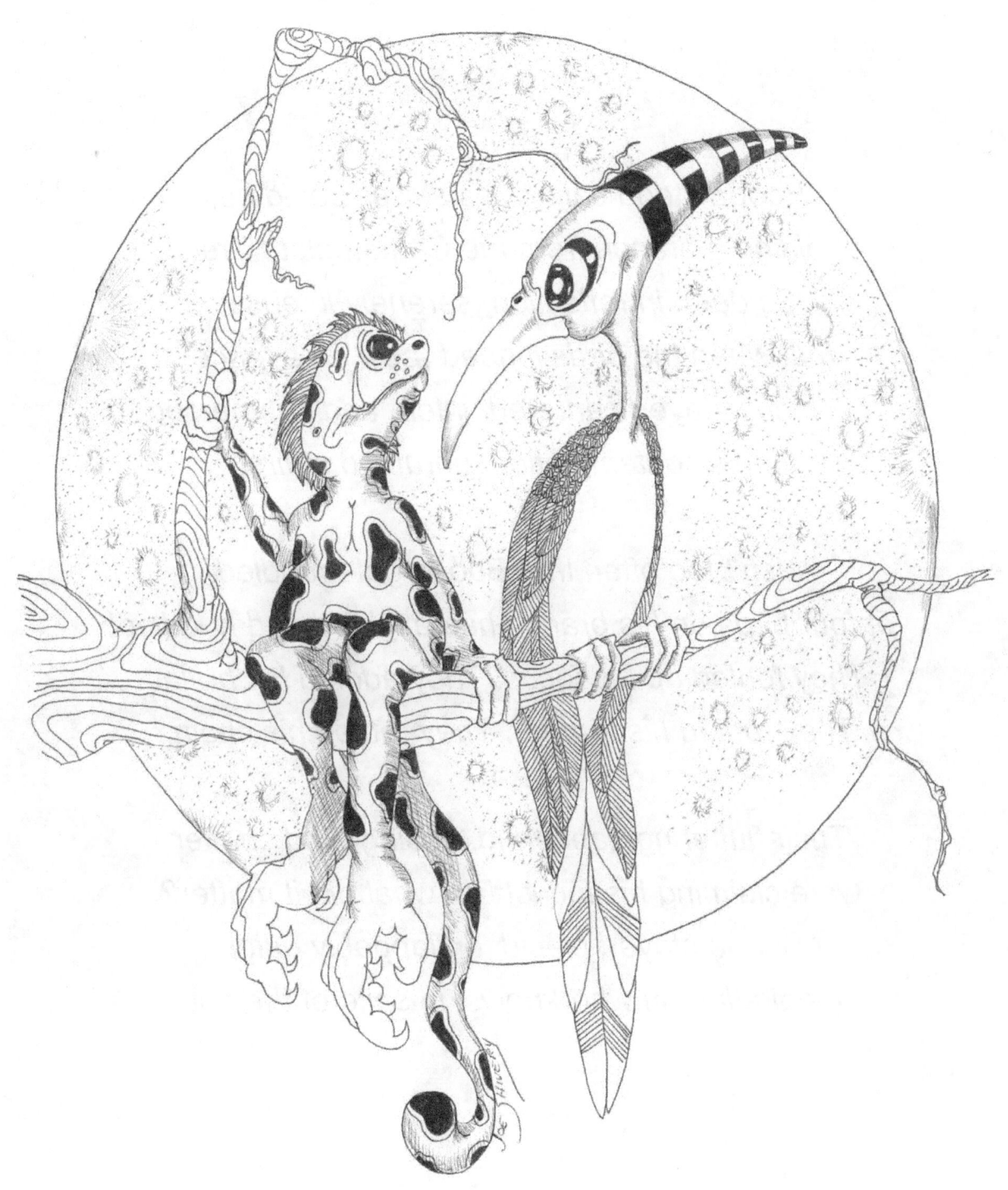

Drawings by Joseph Shivery

Booda and the Birds

Booda stood calmly, as still as could be,
holding a branch from the Contemplate Tree.
So deep in reflection, serenely intense,
that when the birds landed (as if on a fence)
his focus stayed centered, intent and submersed
in his contemplation, unruffled at first.

It isn't too often that Booda got muddled,
yet four birds on his branch had alighted and huddled!
They fouled up his focus. They addled his brain.
They ruffled his feather. They rattled his chain.

Their fluttering, jabbering, cooing, and chatter
were claiming his focus! But what did it matter?
Booda stayed placid, unflappably quiet,
meditating on who-knows, in spite of the riot!

Stories by Kate (The Quill) Britt

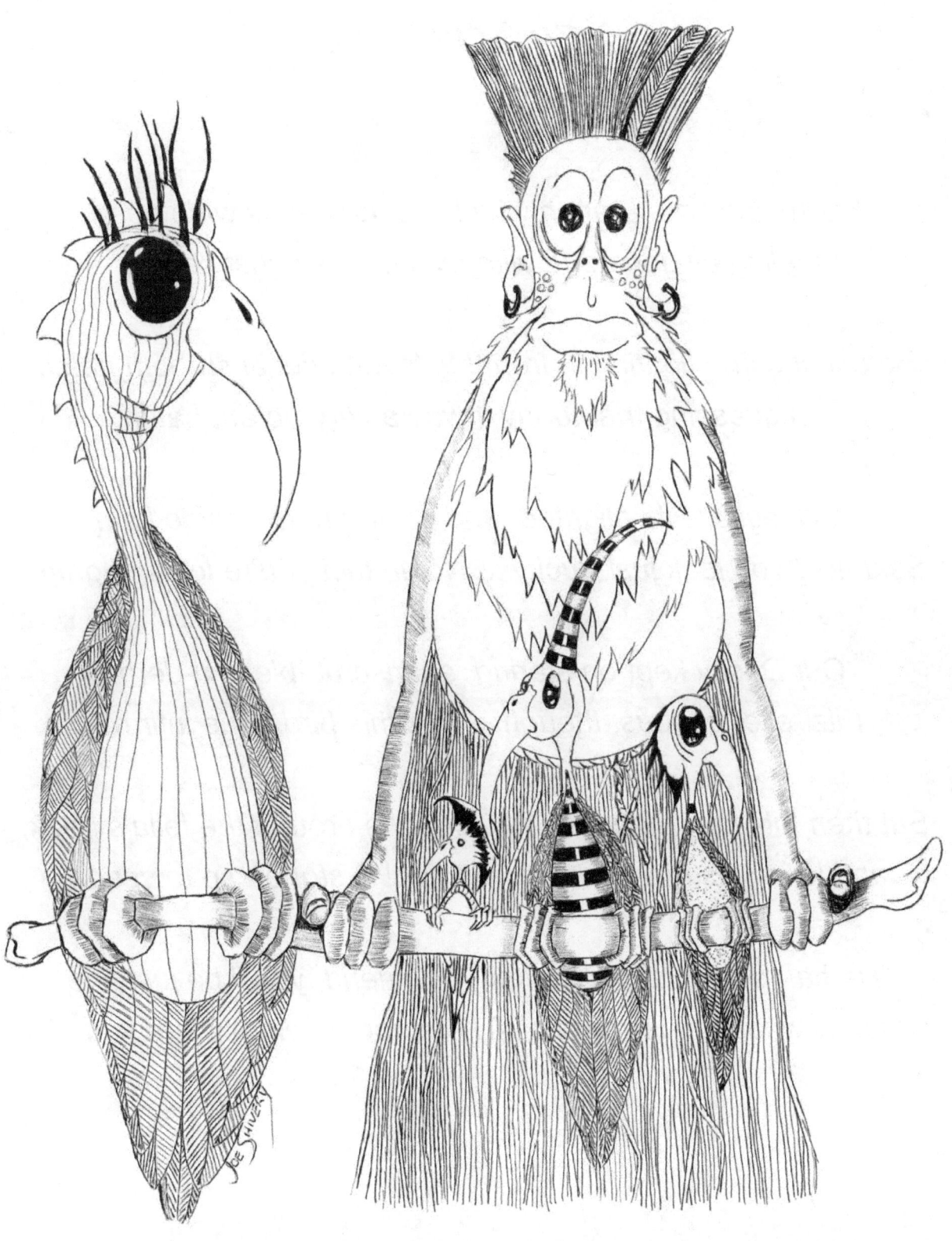

Drawings by Joseph Shivery

Scroomed

He settled on a branch with his buggy eyes wide open,
feeling all gone out, with his tiny brain just copin'.

He'd just come floating in from his favorite local shroom patch.
I'm guessing that today it was a very potent batch.

X-Checker Fitz alighted, and settled right beside him.
Said he, "You look just ducky.... No, in fact you're looking grim."

Our Ducky kept on staring, an inscrutable taxi-derm.
Fitz, ever curious, thought, "Has this bird gone infirm?"

But then Fitz saw the spore-like crumbs around the fella's beak,
and knew his friend was scroomed! A stoner, so to speak.

"Ha ha!" said Fitz X-Checker. "My friend, you'll be just fine.
You know what quacks me up? The shroom fields where you dine!"

Stories by Kate (The Quill) Britt

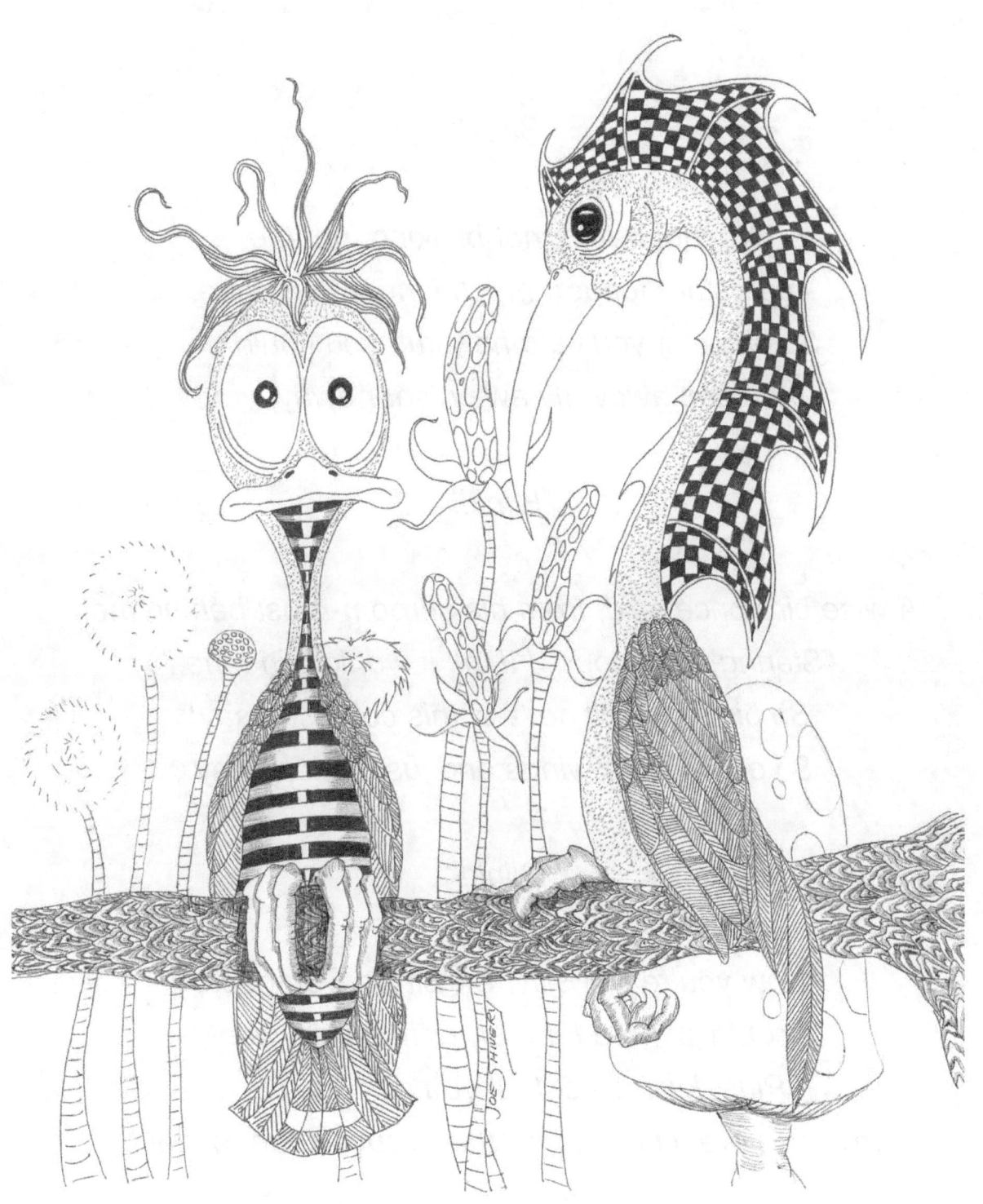

Drawings by Joseph Shivery

The Staring Contest

"Blink!"

No, not never, not blinking, not me.
I can stare longer, much longer than thee.
So birdie, if you've other stuff you could do,
then flap away, fly away, soar away, you!

"Blink!"

A wise bird once said, from his shroom-roost behind me,
"Staring's not good. I think it would blind me."
So birdie, you'll not win this contest, I say!
So open those wings and just flutter away.

"Blink!"

Now you're just silly, Sir Birdie, you geek.
I could sit here forever, or maybe a week!
Plus, I win a contest you didn't expect:
my eyes are much bigger than yours! Give respect!

Stories by Kate (The Quill) Britt

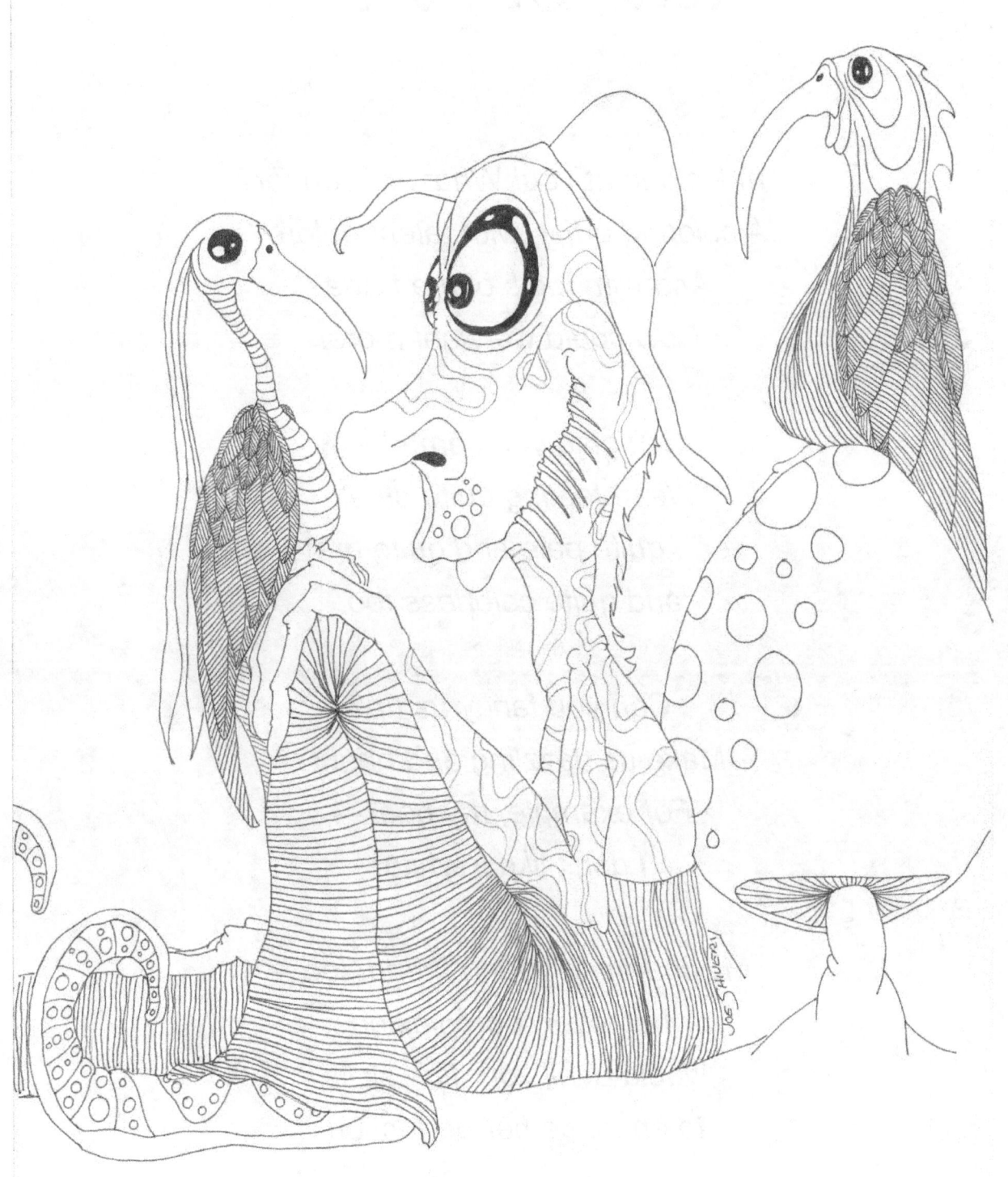

Drawings by Joseph Shivery

Hello Out there!

I'm looking at you! What are you for?
A coloring artist, with talent galore?
And with tools of the trade?
How could we want more!

I'm glad you came by.
We're feeling quite blue...
er... quite pale and quite grey,
and quite colorless too.

Can you fancy us up?
Make us dazzling and bright?
For example, my beak—
I don't like it white!

My charming young friend, too—
her lovely complexion
would avail your fine skills,
to enhance her perfection.

Stories by Kate (The Quill) Britt

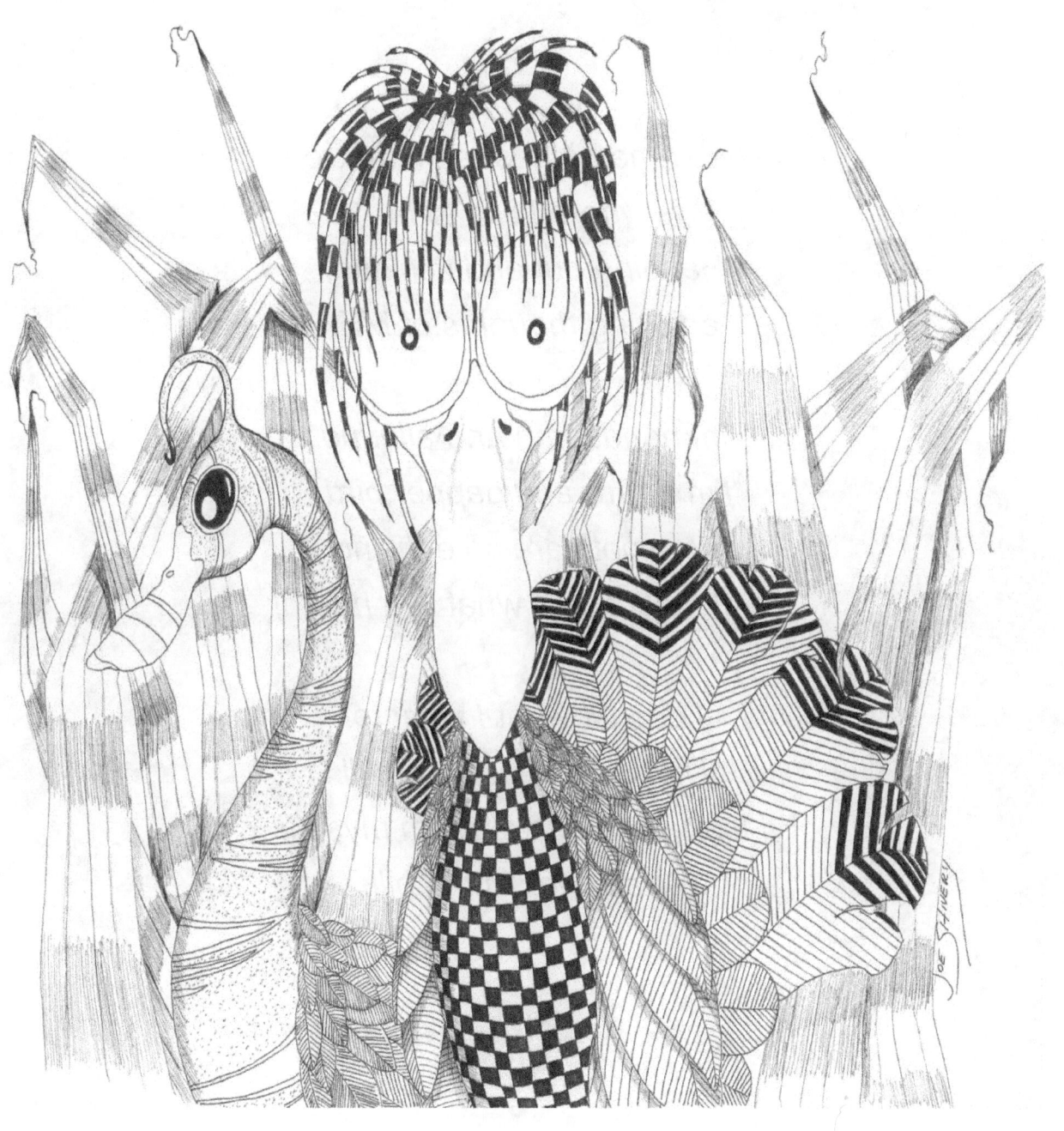

Drawings by Joseph Shivery

Shroom Bird

*Under the biggest shroom tree
is where I like to be.
Hanging out and thinking,
enjoying thoughts of ME.*

*I'm handsome and alluring,
I'm a rare and dapper bird.
My spots are so enticing
—at least that's what I've heard!*

*I do just what I want to.
That's why I stay so still.
I look just like a shroom myself!
A tall one, with a bill.*

Stories by Kate (The Quill) Britt

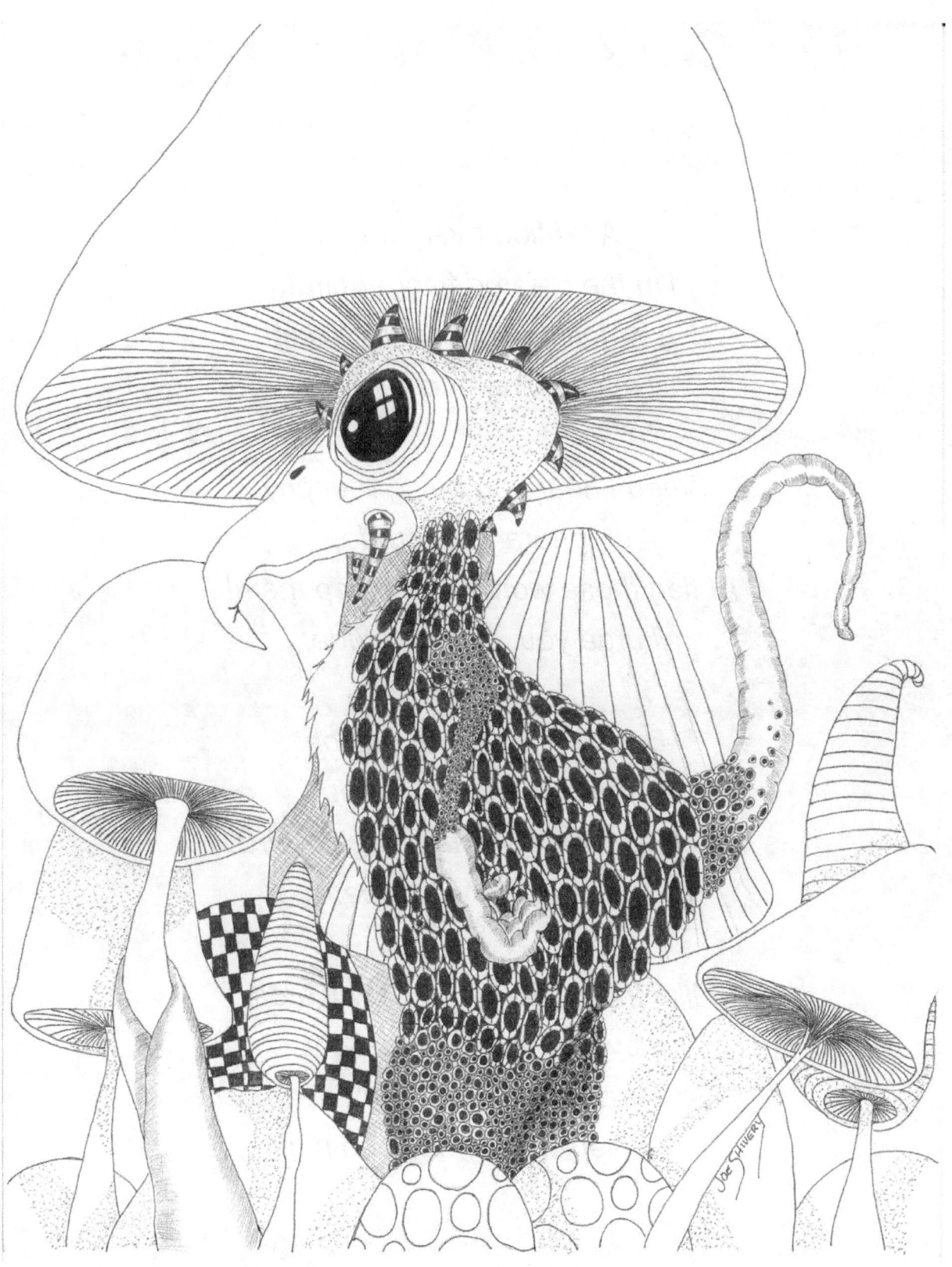

Drawings by Joseph Shivery

The Crested Bleep Flagger

Attention everyone!
I'm the crested flagger bird!
I'm watching you! I'm listening!
I'm catching every word.

When I hear you being raunchy,
or ignorant, or crude,
I'll flag those words and bleep them!
I urge you, don't be rude.

But! Secretly I like my job.
I enjoy a cussing spree!
Don't tell my boss this flagger bird
is listening with glee.

I like those bleeping nasty words,
they give me such delight.
So keep me occupied, my dear...
use bleep-words, day and night!

Stories by Kate (The Quill) Britt

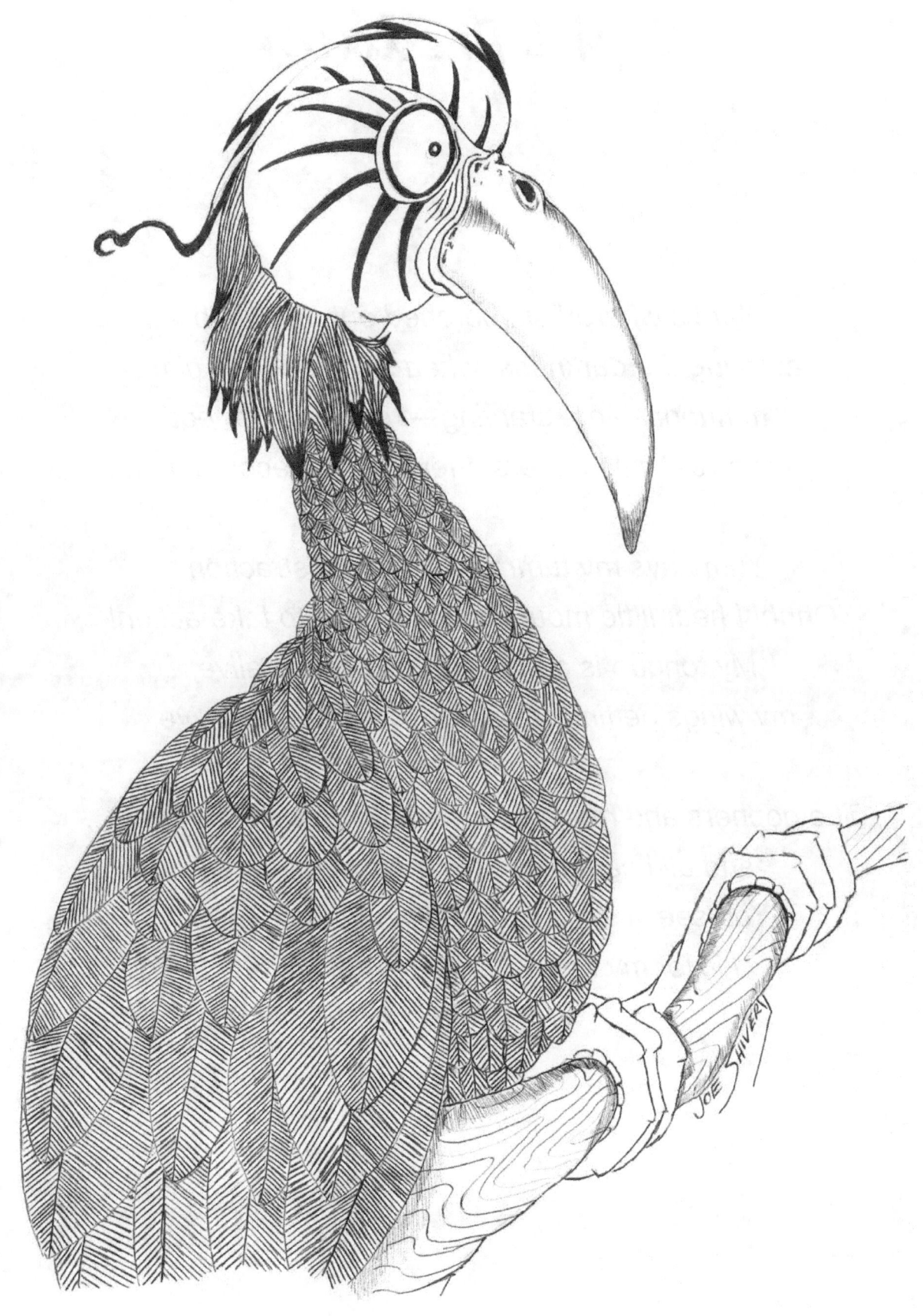

Drawings by Joseph Shivery

Night Predator

Here's where I sit, perched out on a limb,
awaiting the darkness, when skylight goes dim.
I'm hungry—no, starving—I can't wait to eat!
Those sweet little critters, they'll soon become meat.

Yum says my tummy. I need a distraction.
Ohhh! I hear little mousies! Can't wait to take action!
My tongue is a-tingling, my senses alive,
my wings getting ready for evening's first dive.

The gophers and mousies all sneak through the grass...
and all I can think of is mousie foie gras!
You see, it's my nature. I just have to hunt.
I kill for my meals. Excuse me. I'm blunt!

Stories by Kate (The Quill) Britt

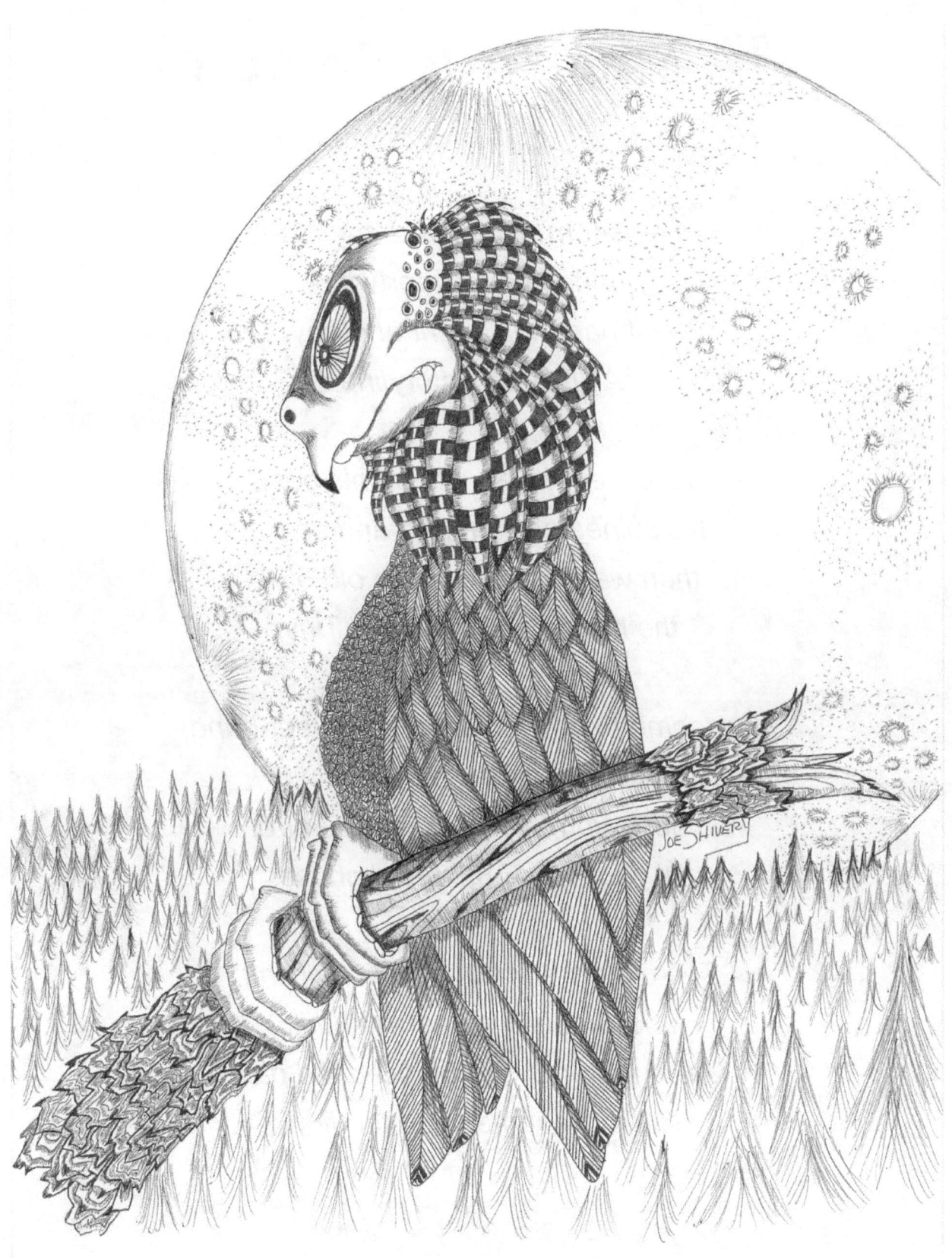

Drawings by Joseph Shivery

The Marriage Proposal

It may seem odd to you, my friend,
when species intertwine.
Yet it happens, night and day....
AND in this storyline!

Jake Heffahorse put on his best,
his spines all starched and shiny,
then went to see a wise old bird,
the mom of Shmee The Tiny.

"I've come to ask for Shmee's sweet hand.
A marriage I propose.
I hope you like me, dear old bird,
it's your child, Shmee, I chose!"

The old gal stared, she didn't blink,
and Shmee just sat in shock.
But in the end, she blessed the pair:
"You're wecome! Join the flock!"

Stories by Kate (The Quill) Britt

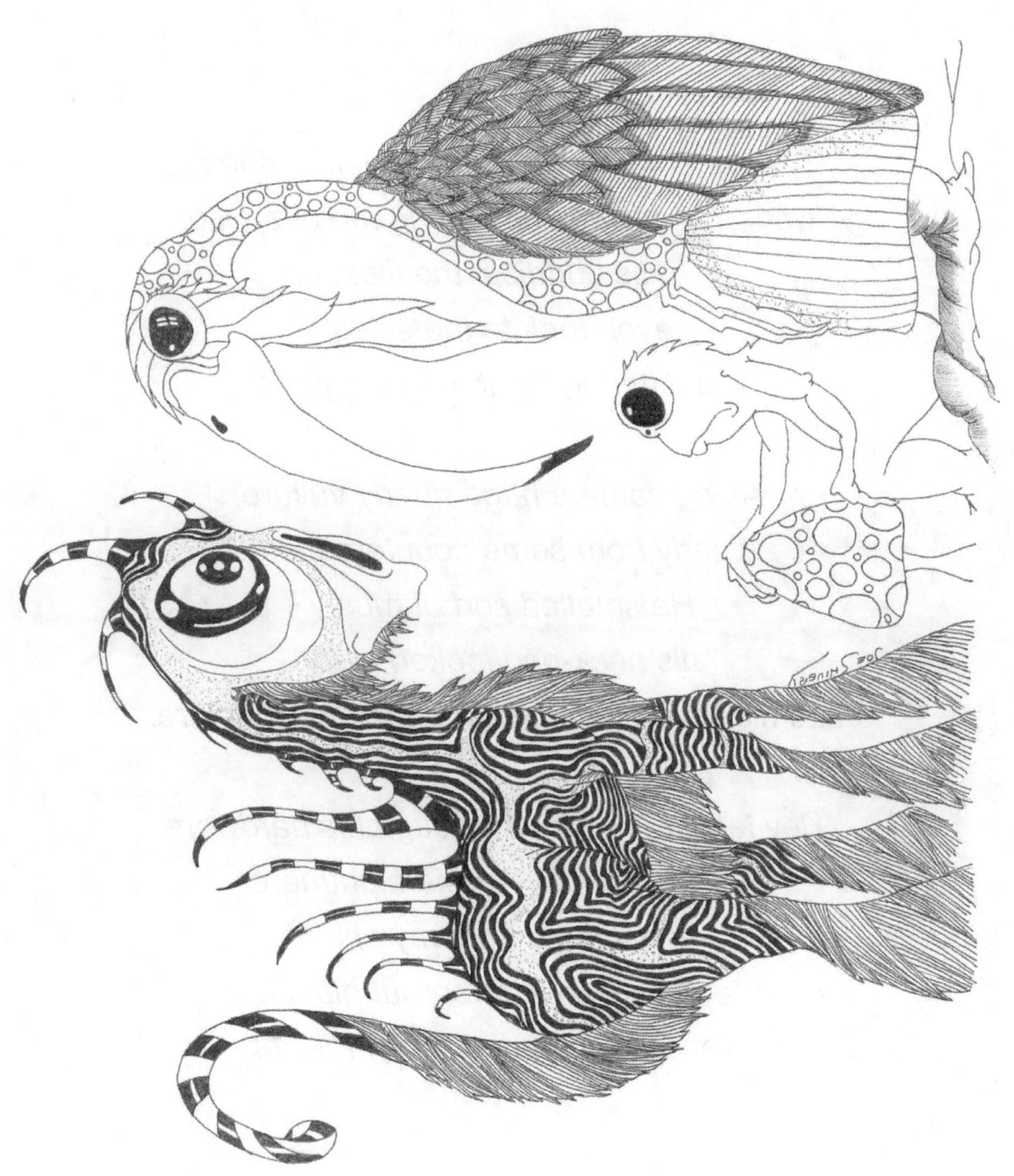

Drawings by Joseph Shivery

Flyface Meets Pierre

There once was a fella named Flyface
whose scent was disrupting the airspace.
His buddies, the flies,
even took to the skies,
in a flittering flight from disgrace.

Along came a huge gnarly vulture,
clearly from some counterculture.
He smelled sort of musty,
his neck-ring looked rusty,
and his beak like a chunk off some sculpture.

"Hey fellas," he lisped through his hardware.
"I've evaded a terrible nightmare.
I've escaped from my chains,
and I've flown the great plains.
Please be my friend? I'm Pierre!"

Stories by Kate (The Quill) Britt

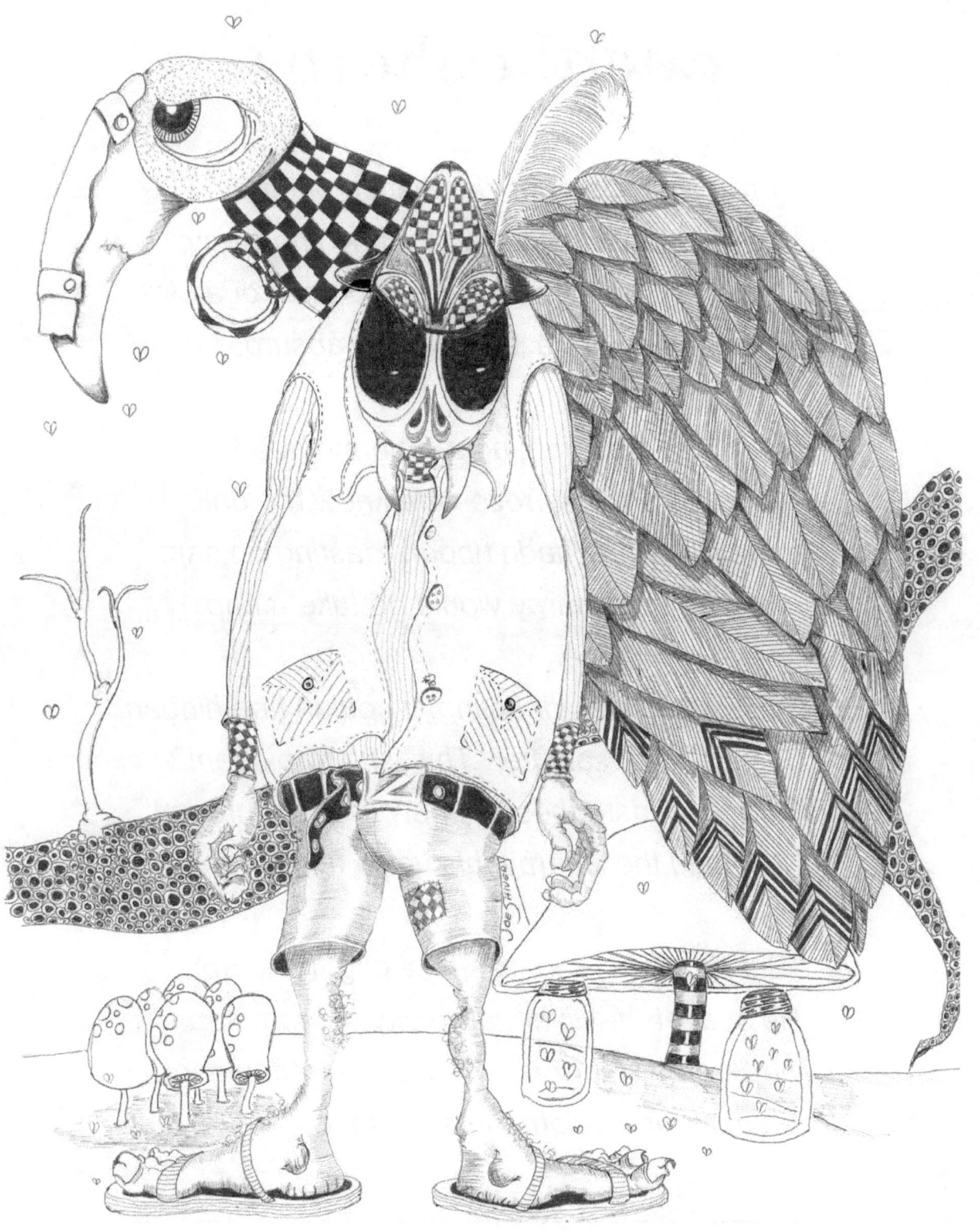

Drawings by Joseph Shivery

Freemont's Lunch and the Sharpy

Froggity Freemont was eating one day,
enjoying the shrooms, just munching away,
when along came a sharp-crested boss of a bird
annoying at best, and often absurd.

The Sharpy was flaming a grumpy-faced chill,
so Freemont just froze—he knew the drill.
He pretended he hadn't been feasting on sap,
wishing the Sharpy would go take a nap.

His shroom-sap was dribbling, it couldn't be hidden.
"Please, Sir," said he, "This isn't forbidden!"
"I needed to taste these. A new kind of shroom!"
"NO!" said the Sharpy, his voice full of doom.

But Froggity Frog wasn't taking this crap.
He spat at the vixen, all sticky shroom sap.
The Sharpy's sharp crest got covered in goo!
As he quickly took flight, he screamed, "I hate you!"

Stories by Kate (The Quill) Britt

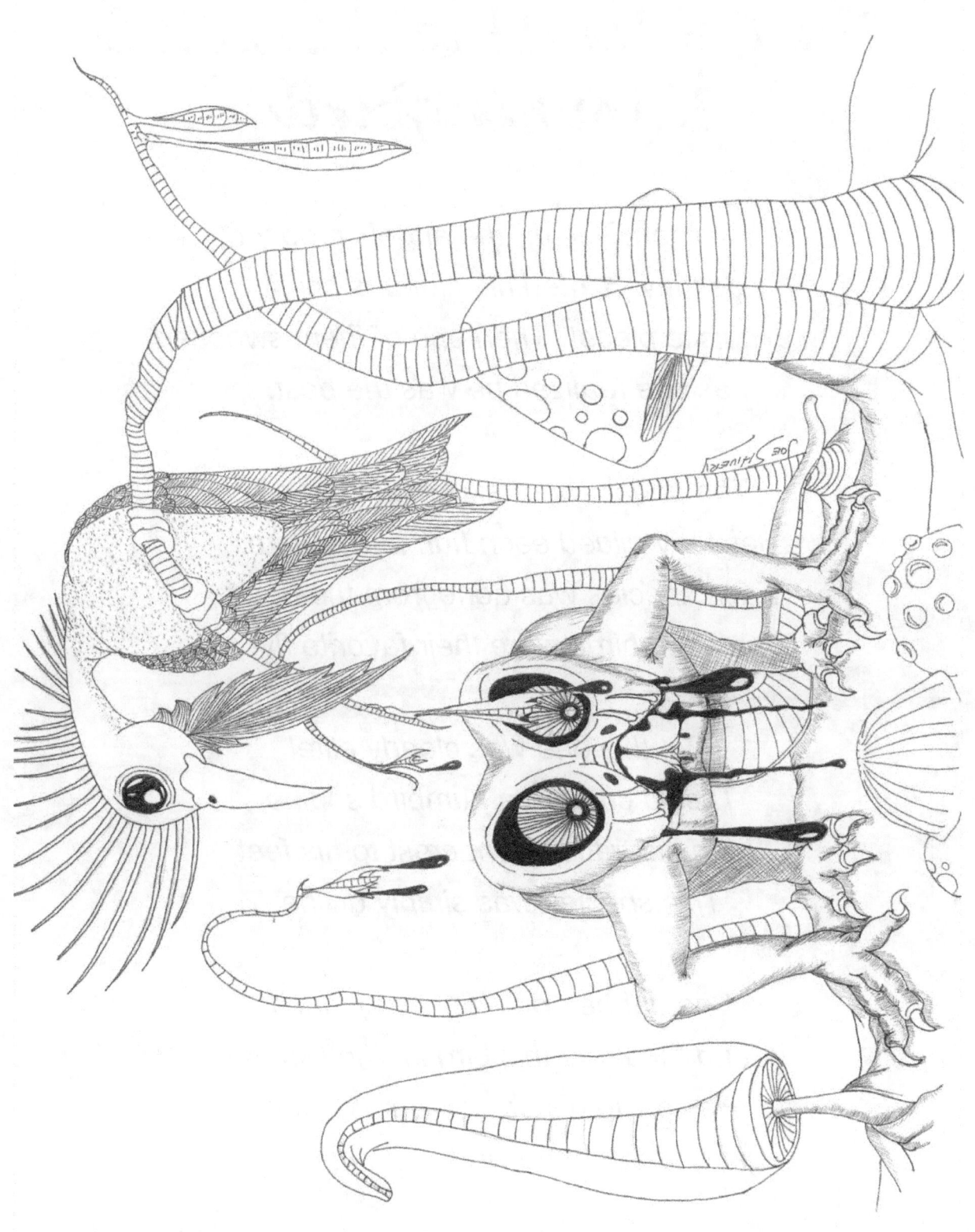

Drawings by Joseph Shivery

The Golden Shield Chested Hummingbird

"A Golden Shield!" the angels crooned,
as they painted his glorious chest.
"An exquisite piece!" Then one of them swooned,
as she realized he was the best.

The angels were skilled at their art,
as they gilded each humbird's attire.
Each species was done from the heart,
for these birds were their favorite flyer.

But this one was clearly elite!
They'd created a humbird so fine.
From his transparent crest to his feet,
This species was simply divine.

She dabbed on a finishing touch,
and recorded this bird in The Book.
He flew to his sap-shroom abode,
and dazzled the world with his look

Stories by Kate (The Quill) Britt

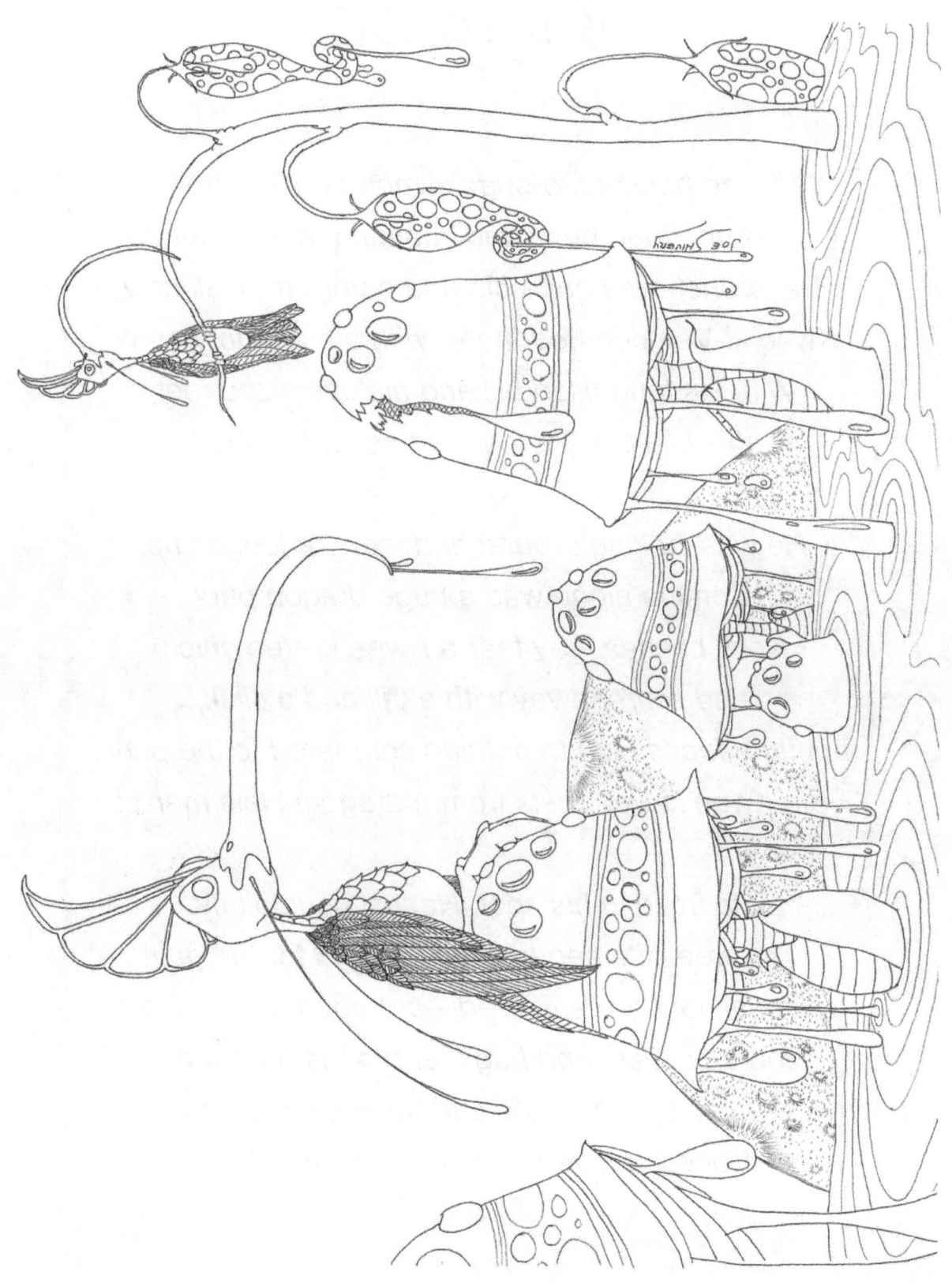

Drawings by Joseph Shivery

BugaBOO

Three handsome bugs climbed up in a tree,
buzzing their buzz and chanting their squee.
The branch was quite big and before they all saw,
Kwee ki-Vee perched there, with a big empty craw.
With his fang-filled bill and his oversized feet,
this is a bird they hoped never to meet!

He was looking around and then he looked up.
Coming along was a huge dragon pup!
Now, beetles may fear a Kwee ki-Vee chick,
and scurry away with a trill and a click,
but their fear's next to nothing compared to the panic
the Kwee ki-Vee feels from a dragon! He's manic!

He froze in his spot. He just couldn't fly.
The wee little beetles, they feared for the guy!
Then all four remembered—a dragon that's young
fears beetles, and bugs, and birds on a rung.
So everyone's safe and no one's a snack.
Nobody move and there'll be no attack.

Stories by Kate (The Quill) Britt

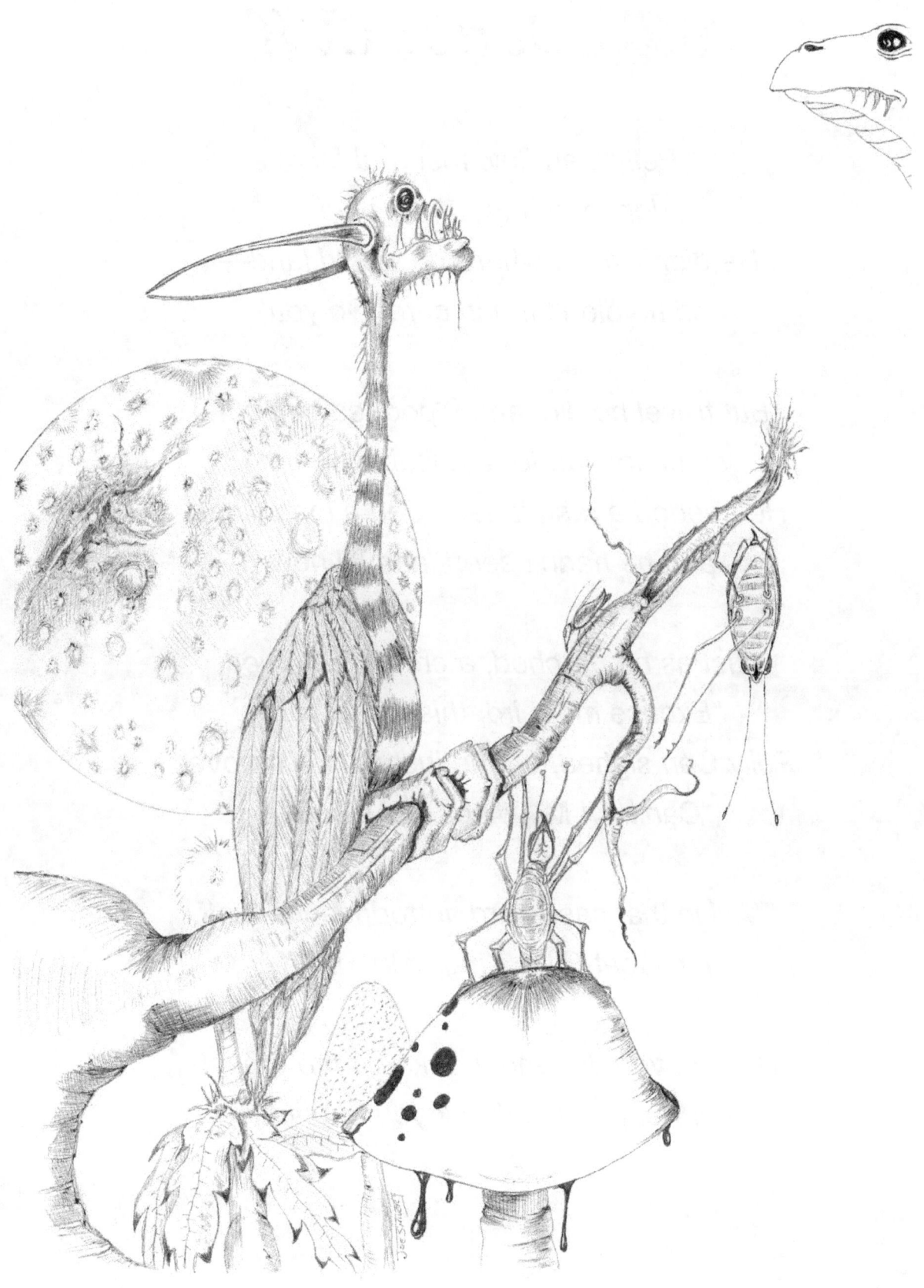

Drawings by Joseph Shivery

Billy Goat's Cliff

*Pelly Can flew fast and far,
right over the briney blue.
He didn't know where he would land—
and he didn't much care. Do you?*

*But travel he did, and it pooped him out,
so he looked for a suitable bough.
He needed a rest, it had been a long flight,
and he hadn't seen land 'til now.*

*Just as he perched, a creature arrived.
"Excuse me, bird, this is MY cliff!"
Pelly Can sighed, but he just couldn't move.
"Can't fly! My wings are so stiff."*

*"Well in that case, bird, introduce yourself.
I'm Goat-Billy, King of the Bluff."*

*"How do you do, and thanks for the branch.
I'm Pelly! Can't thank you enough."*

Stories by Kate (The Quill) Britt

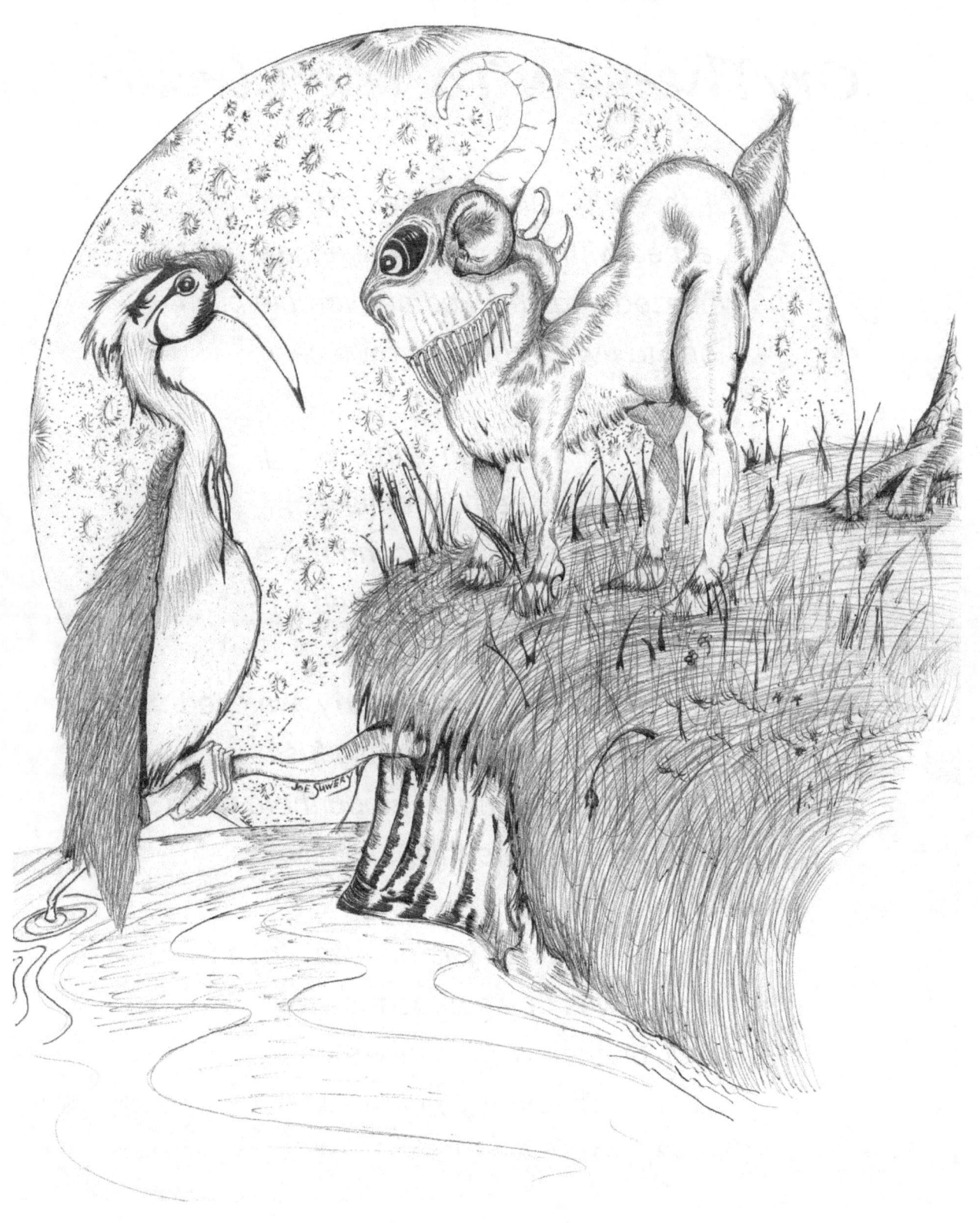

Drawings by Joseph Shivery

It Happened
On The Way To The Circus

MJ, the long-haired hippie-bird chick,
gasped with her open-beaked jaw.
She wheezed and shrieked at a terrible pitch,
one to rival a cowed crow's caw.

Trey, the Piled-High Turtle-Doug,
opened his beak and hissed.
A terrible, moaning, hooting noise.
He sounded really pissed.

Drobbie, the doe-eyed Dingleberry, watched.
He didn't know why the big fuss.
But he hacked a wee cough and stood there quite still.
Perhaps there were things to discuss.

I guess I'd better tell you now, my friend,
what it was that got them started.
Well, on their walk to the local fair,
Dingleberry farted!

Stories by Kate (The Quill) Britt

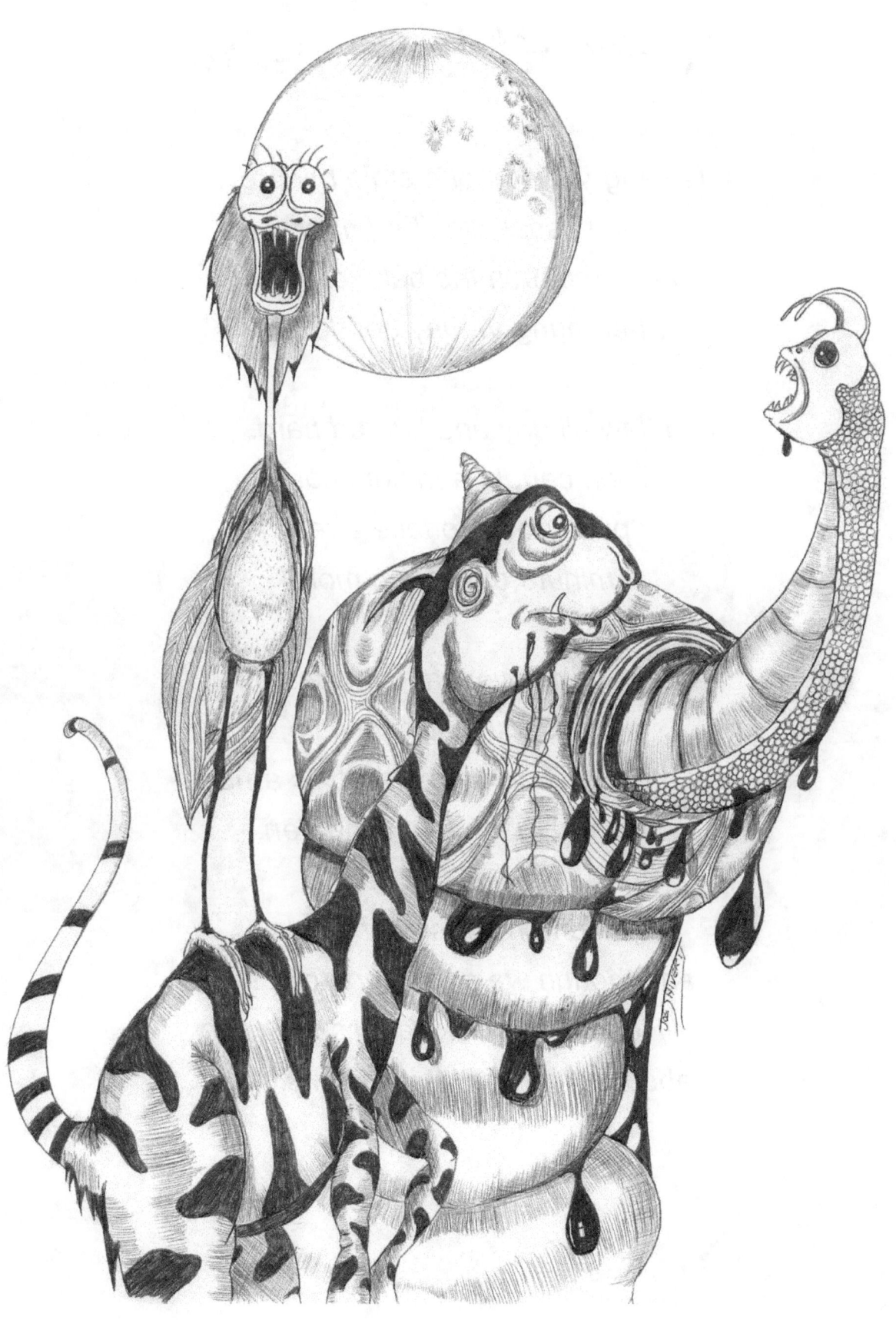

Drawings by Joseph Shivery

Hornbill's Lament

I'm angry. Someone stole my prey.
The missus won't be happy.
Not to mention the baby chicks—
when hungry, they get flappy.

I flew all day and hunted hard.
Then caught a major score.
I put it down to take a rest,
a minute or two, no more!

I opened my eyes, and it was gone!
I guess I should try again.
But the sun is gone, the moon's a-risen
I have to get back to the den.

Well tomorrow is another day
and though we go hungry tonight,
I will teach the chicks a lesson or two
about keeping all thieves in sight.

Stories by Kate (The Quill) Britt

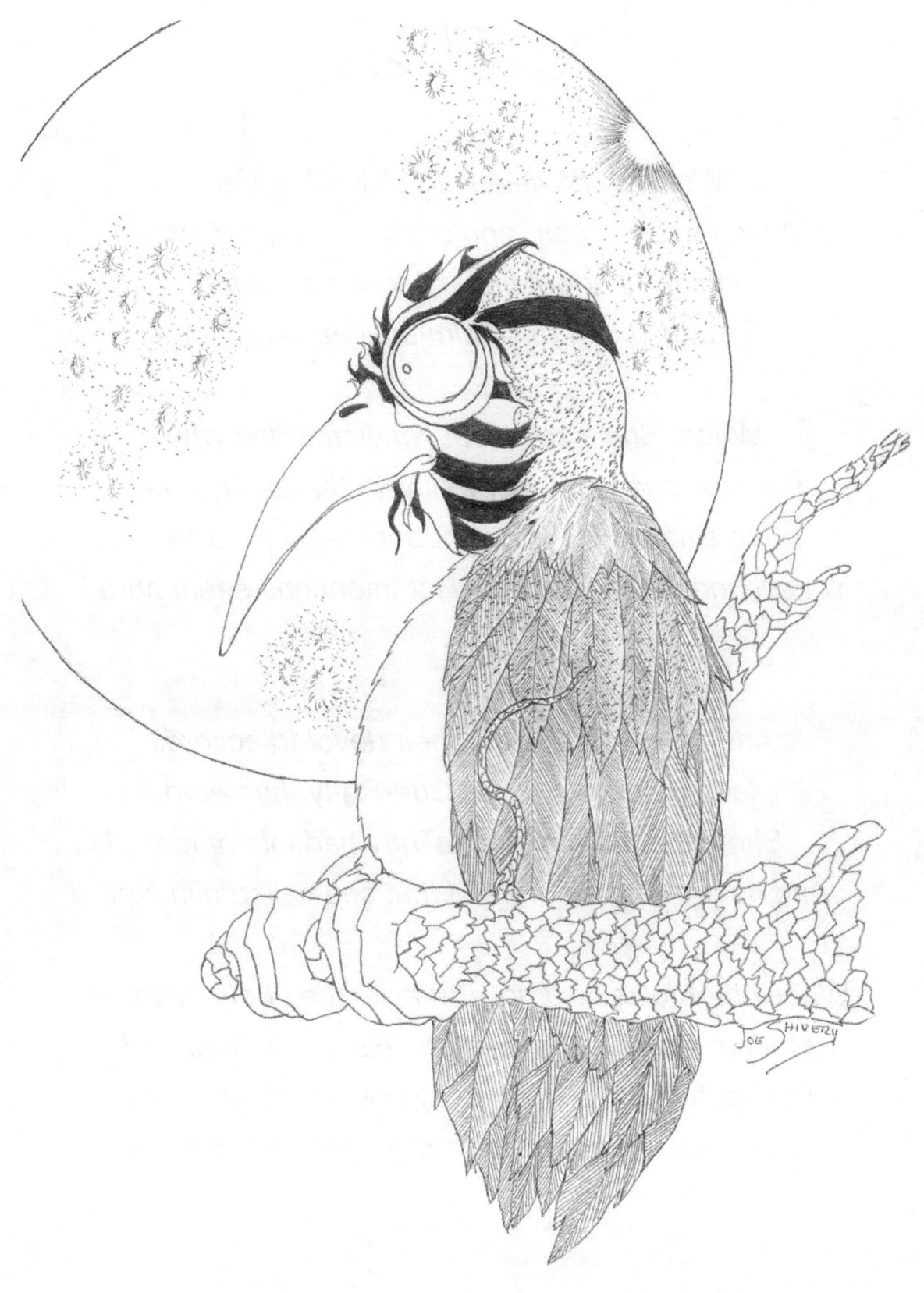

Drawings by Joseph Shivery

Kindred

"What a cute little fella! Adorable size.
A nice head of hair, and those darling big eyes!
I think I'll adopt him, he looks so alone.
Perhaps I can raise him until he is grown."

"Whoa! She's so close! I'm wondering why.
Perhaps she can't see well with that pretty eye?
I'm small and I'm tough, but I feel insecure.
Yet she looks very friendly. Her intentions seem pure."

And thus it all started, their devoted accord.
Madam La Plume and Curl-Raffy, her ward.
She cared for him daily. They had lots of fun.
And he grew up so grateful that she called him son.

When other folks said how un-alike they both seemed,
Madam would just smile, and Raffy—he beamed!
For each of them knew, way down in their hearts,
they'd been meant to be family right from the start.

Stories by Kate (The Quill) Britt

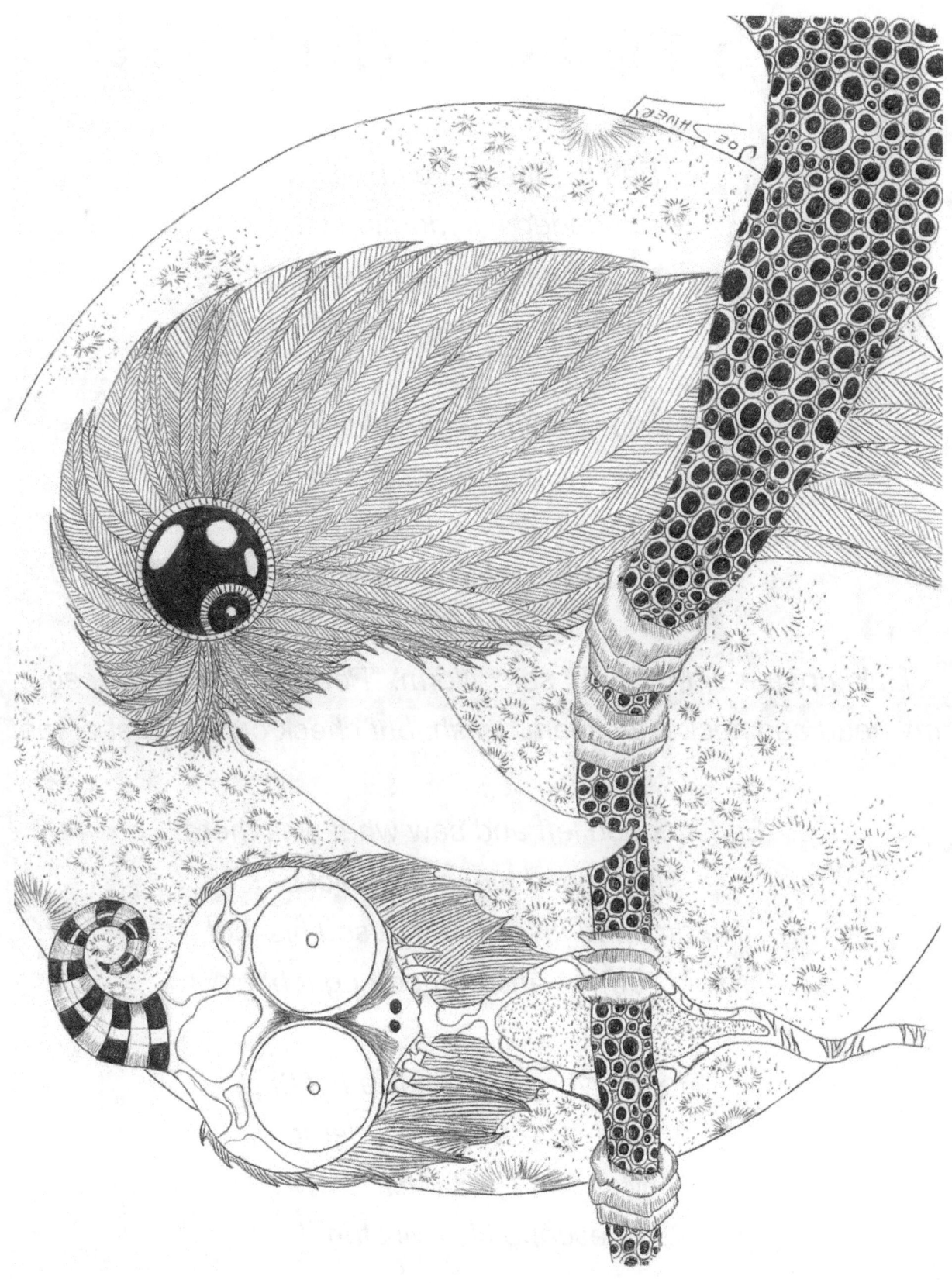

Drawings by Joseph Shivery

Early Bird Gets The Worm?

Earl E. Bird woke up today
and needed his morning feed.
Flew to the nearby shroom field,
hoping for juice or seed.

Peeking out of a big ol' shroom
was an inviting bite-sized worm.
"That one looks delectable—
ever so juicy and firm!"

"Hold up, there, Mr. Bird," said Worm. "Perhaps you didn't see...
my head and neck may seem delish, but check out the rest of me!"

Earl stepped left and saw what was there.
It stopped him in his tracks.
He dropped his tail and raised his foot,
said "Oops!" and stepped right back.

He'd never seen the likes of this!
A worm with a snake's derrière!
"Maybe if I just back away,
I'll escape his evil stare."

Stories by Kate (The Quill) Britt

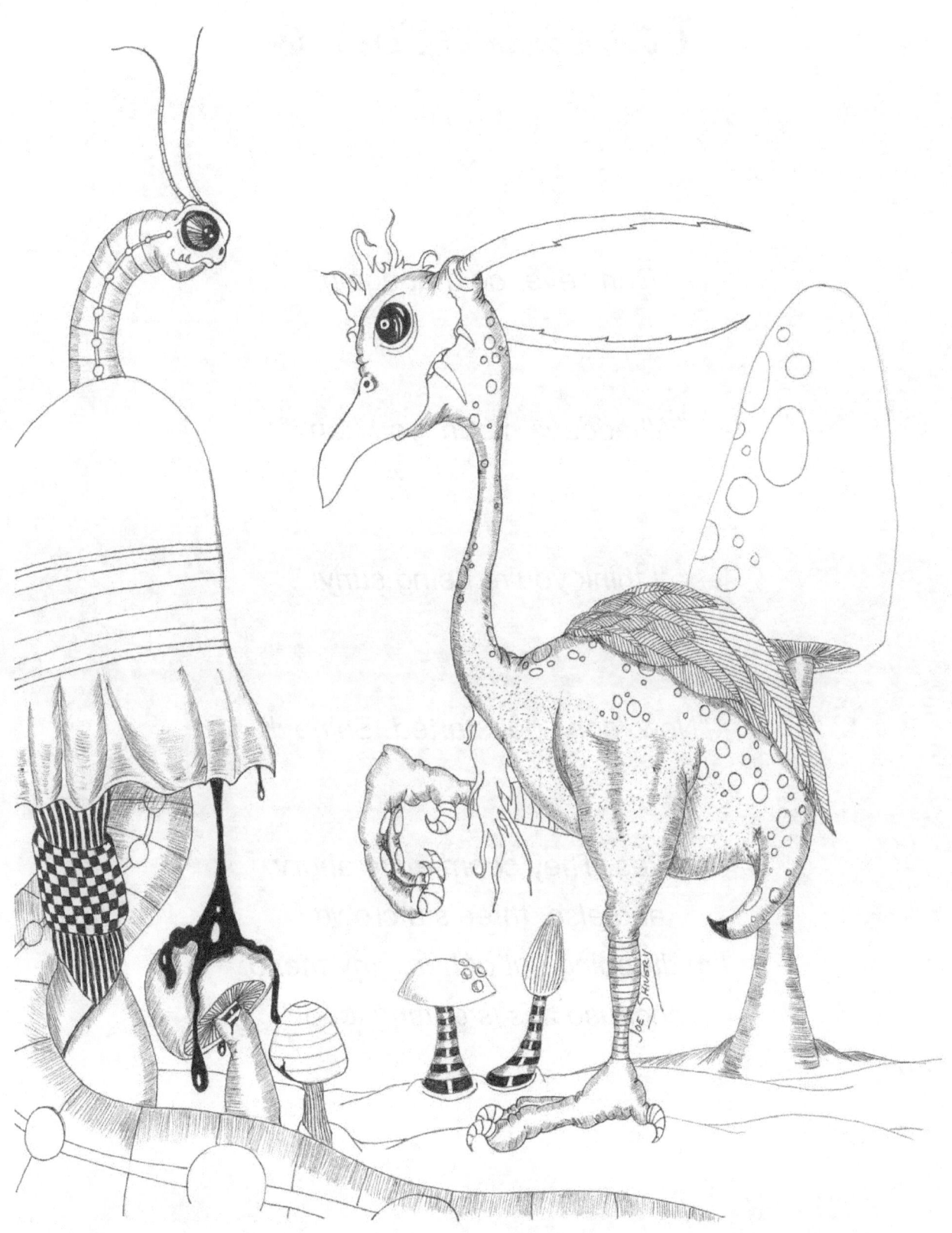

Drawings by Joseph Shivery

Eavesdropping

"Don't ever do that again!"

"Whaddaya mean, you hen?"

"I think you're being surly!"

"Now, don't get started, Shirley!"

"Yikes. They seem quite angry,
and also, three's a crowd.
I'm dropping out of here, my friend,
because this is getting loud!"

Stories by Kate (The Quill) Britt

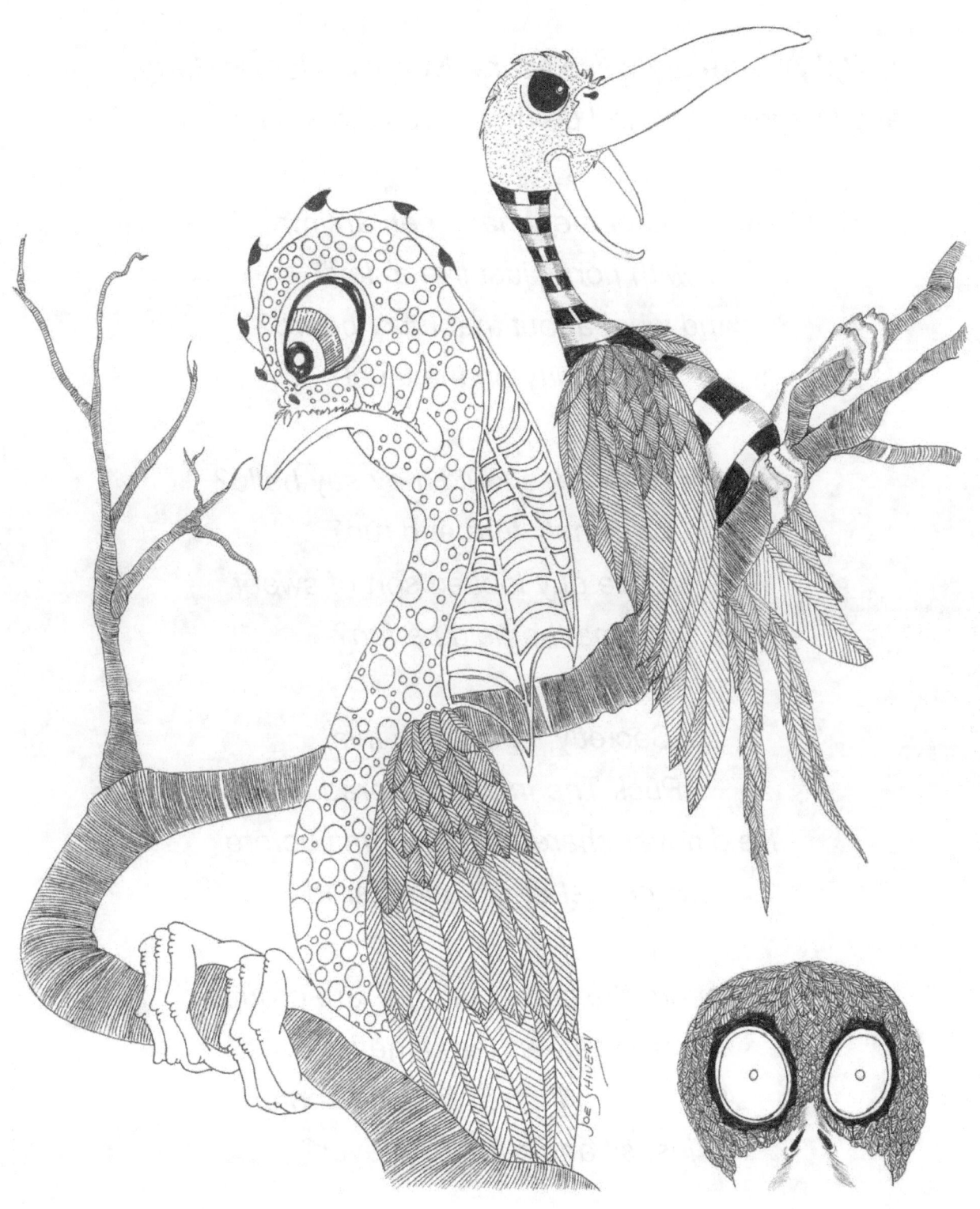

Drawings by Joseph Shivery

What Are The Odds?

Sally Secretary wasn't sure. Nor was Hornet Harry.
Baby Dragon remained demure. Was that an imp? or fairy?

None of them had seen an imp
with horns just like a devil.
And what about that hairy beard?
Is this guy on the level?

Each wondered, should they say hello?
Or simply turn and run?
And yet, the guy looked sort of sweet,
so maybe he'd be fun?

Secretly, I'll tell you this.
Puck The Imp felt scared.
He'd never shared his shrooms before,
so he just stood and stared.

What are the odds that this rare group
would gather here together?
And, frozen in their favorite spots,
just sit and stare? Forever?

Stories by Kate (The Quill) Britt

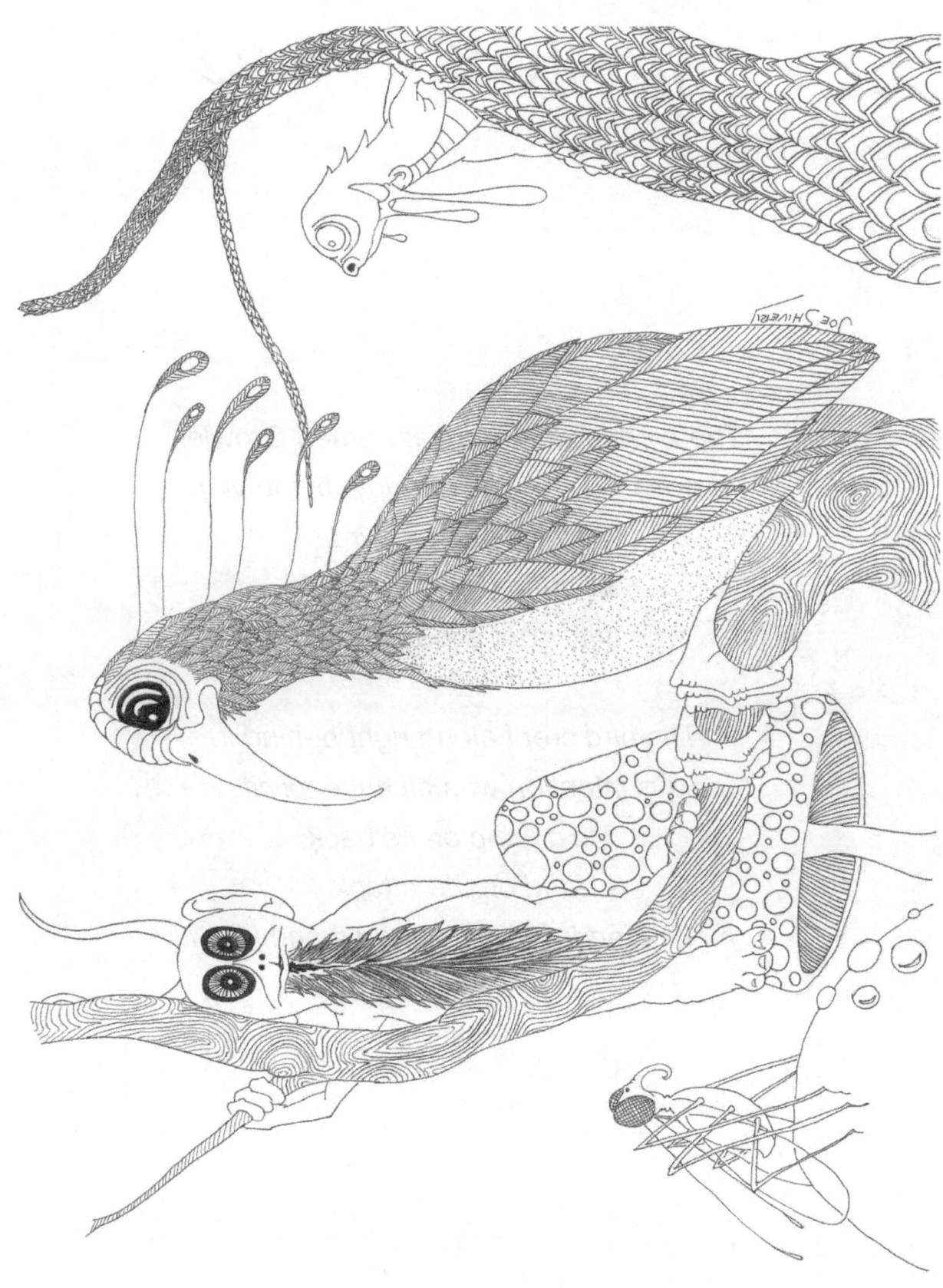

Drawings by Joseph Shivery

Growler's Surprise

There once was a rattler named Growler,
whose visage was grumpy, but fowler.
Along came a bird,
all stripey and spurred,
who'd just got a job as a prowler.

The bird crept along right behind it,
his intention was all but explicit:
He'd jump on its back,
fend off the attack,
make friends, then just hug it and kiss it!

Stories by Kate (The Quill) Britt

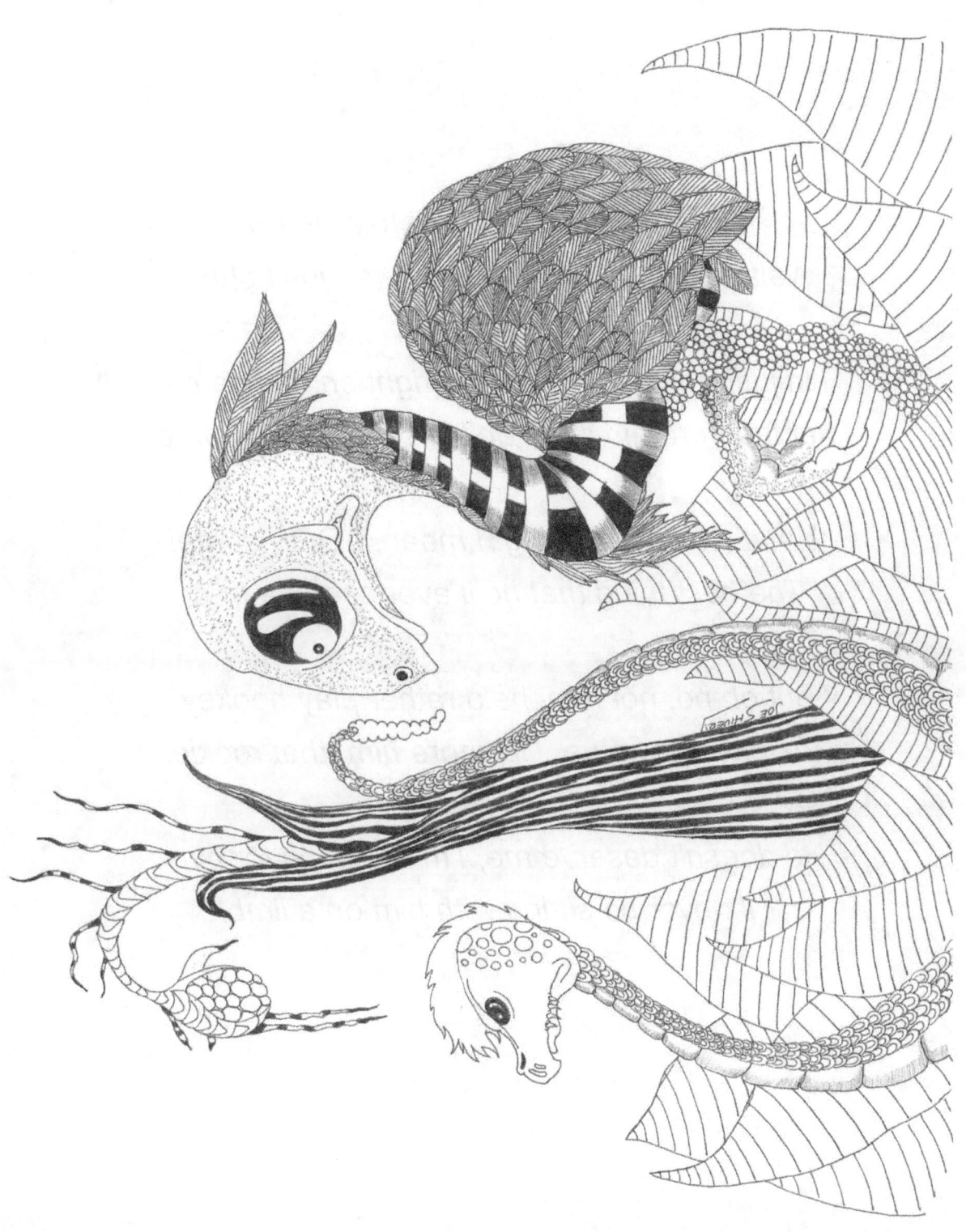

Drawings by Joseph Shivery

Never Date a Featherbrain

All dressed up and nowhere to go.
Waited for my new date, but he didn't show.

I'm just going to stay here, right on this perch.
That featherbrain shouldn't leave ME in the lurch!

What was he thinking. I mean, LOOK at me!
The best thing that he'll ever see in a tree!

But oh no, not him, he'd rather play hookey.
So if he shows up, I'll ignore him, that rookie.

He doesn't deserve me, I'm too good for him.
I'll never be sitting with him on a limb!

Stories by Kate (The Quill) Britt

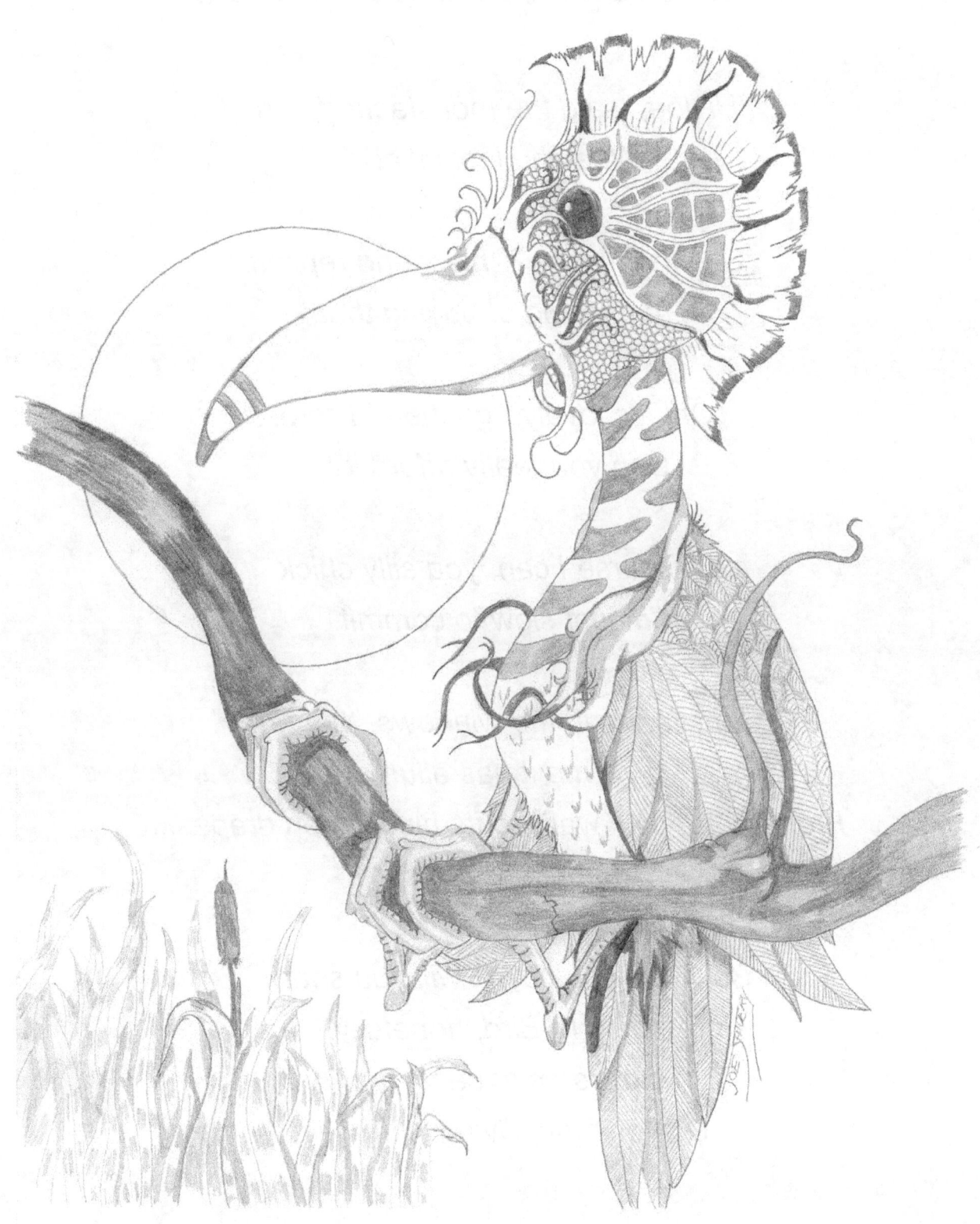

Drawings by Joseph Shivery

The New Roommates

"Hi Joe," said the moustached bird.
"Whatcha lookin' at?"

"See that house?" his friend replied.
"I'm thinking of buying that!"

"Oh! It's lovely," gushed M-Bird.
"Can you really afford it?"

"Of course I can, you silly chick.
I'm just slow to commit.

I'm staring in the windows, though.
To me it has allure.
From its hot pink walls to its blue-green drapes...
Yup, I guess I'm sure."

"So when you buy it, will you share?"
asked M-Bird, hopefully.
"Mi casa es tu casa, friend,
Do you fancy living with me?"

Stories by Kate (The Quill) Britt

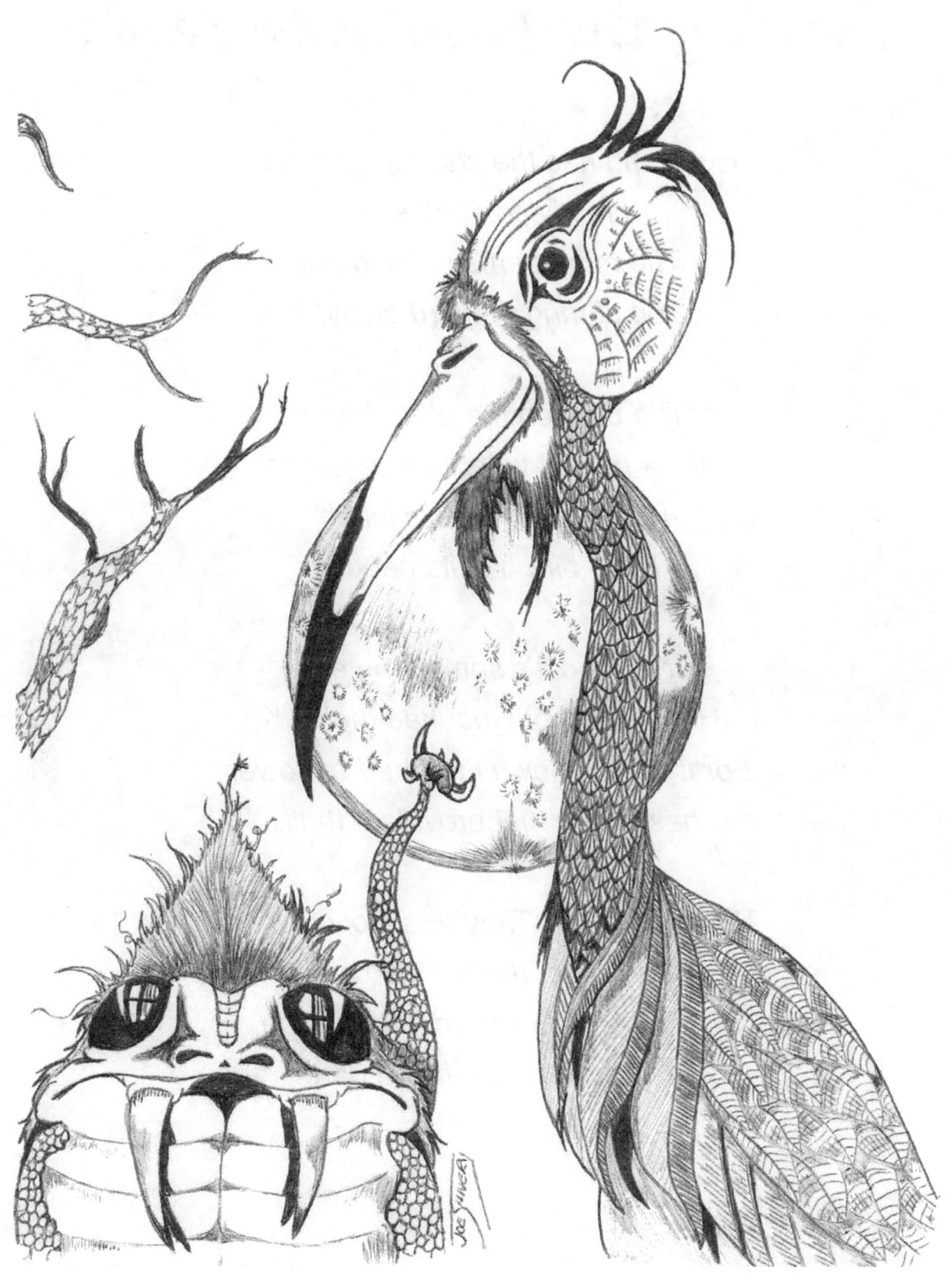

Drawings by Joseph Shivery

Sharing the Funflower Seeds

How long has the staring gone on?
I really couldn't say.
The bug seems quite intent
on staring the bird away.

The bird, on the other hand,
I think he just wants those seeds.
He's hungry for his lunch.
A big bird has its needs!

Or maybe it's something else.
Have they both just had their fill?
For it's well known that the Funflower
has seeds that provide a thrill.

That must be it! They're simply stoned!
They've got that wasted stare.
Those berries will do it to anyone,
so have some—if you dare!

Stories by Kate (The Quill) Britt

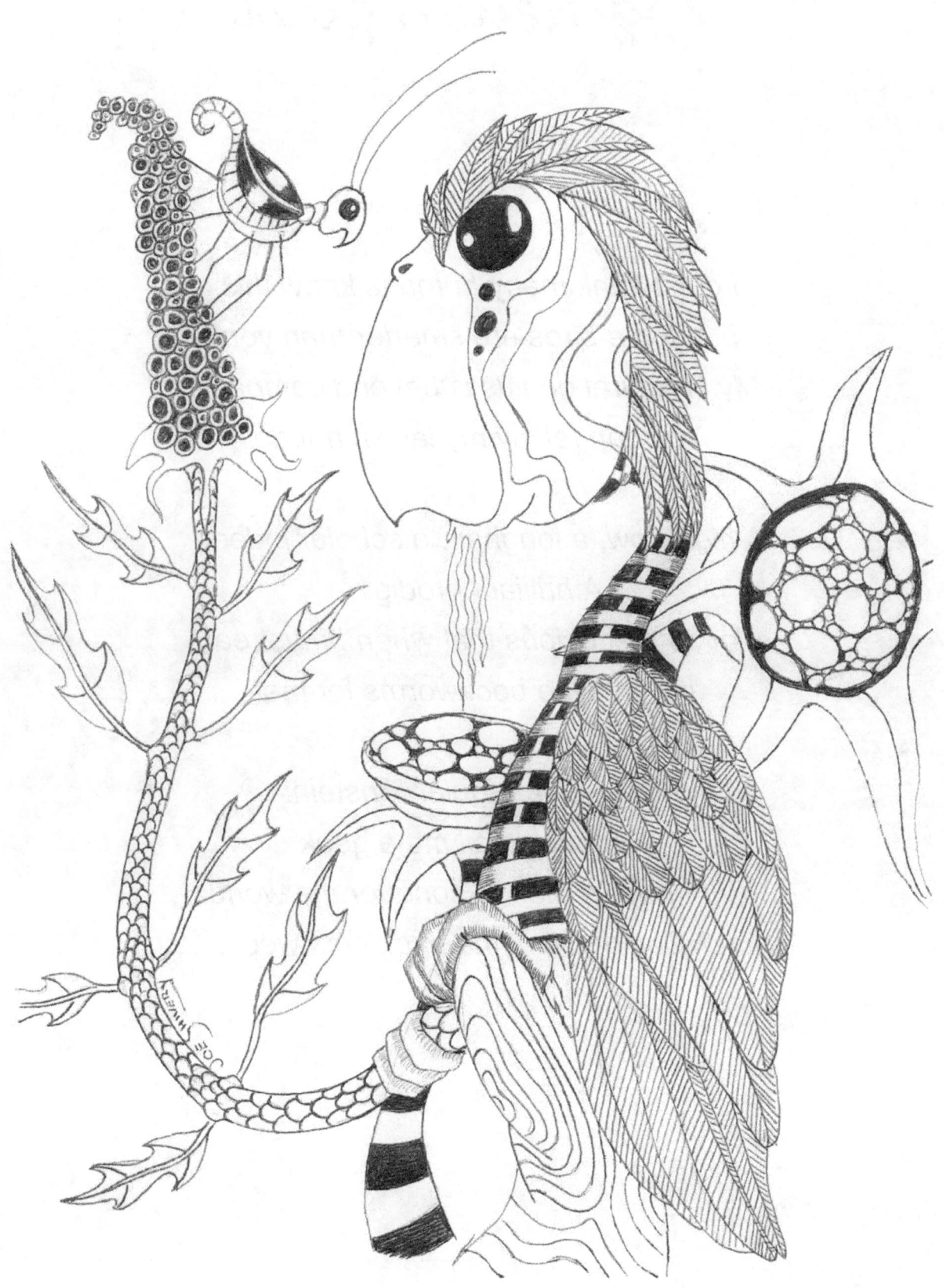

Drawings by Joseph Shivery

Egg Head Egoist

I don't think many humans know this,
but some birds are smarter than you!
My creatural genius is beyond compare!
You can tell by my lavish hairdo.

A highbrow, a longhair, a scholar indeed.
A brilliant prodigy.
I'm so precocious that when I must eat,
it's only the bookworms for me!

Yes, I'm a regular Einstein!
You might call me a geek.
But I have a plan to conquer the world.
How? Could you come back next week....?

Stories by Kate (The Quill) Britt

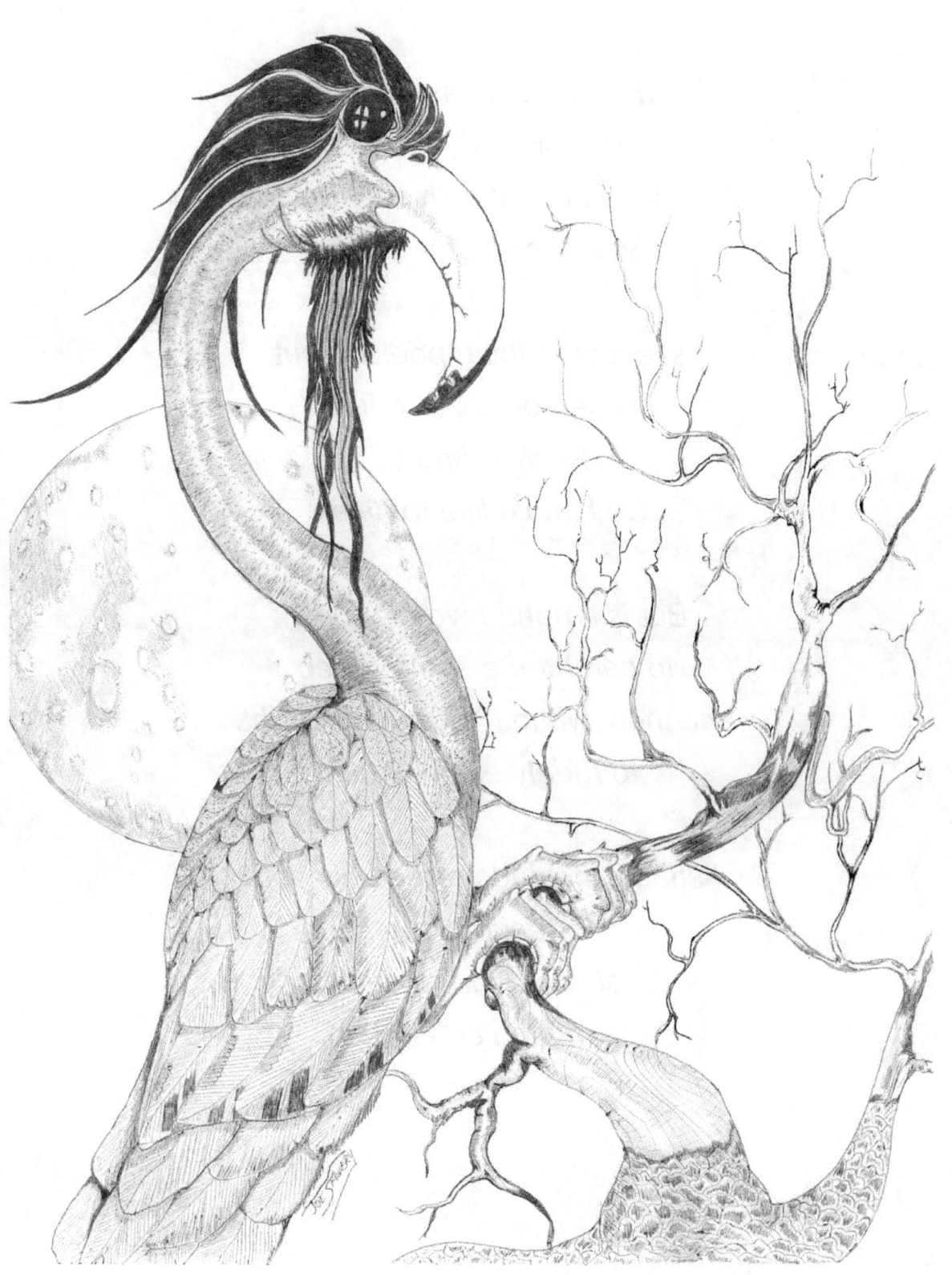

Drawings by Joseph Shivery

Refection Conundrum

I'm thinking. Just a minute now.
Have I seen this before?
A spotted branch with pointy pods.
Such wonderful decor!

I see a wee thing peeking out,
his camouflage so fine.
I wonder if he knows I do?
On him I'd like to dine!

But is it right, I wonder now,
to perch on a spotted tree
and then, without another thought,
to rudely eat its flea?

I should instead pretend his dots
are perfect obscuration,
and just enjoy this spotty world
with full-on admiration.

Stories by Kate (The Quill) Britt

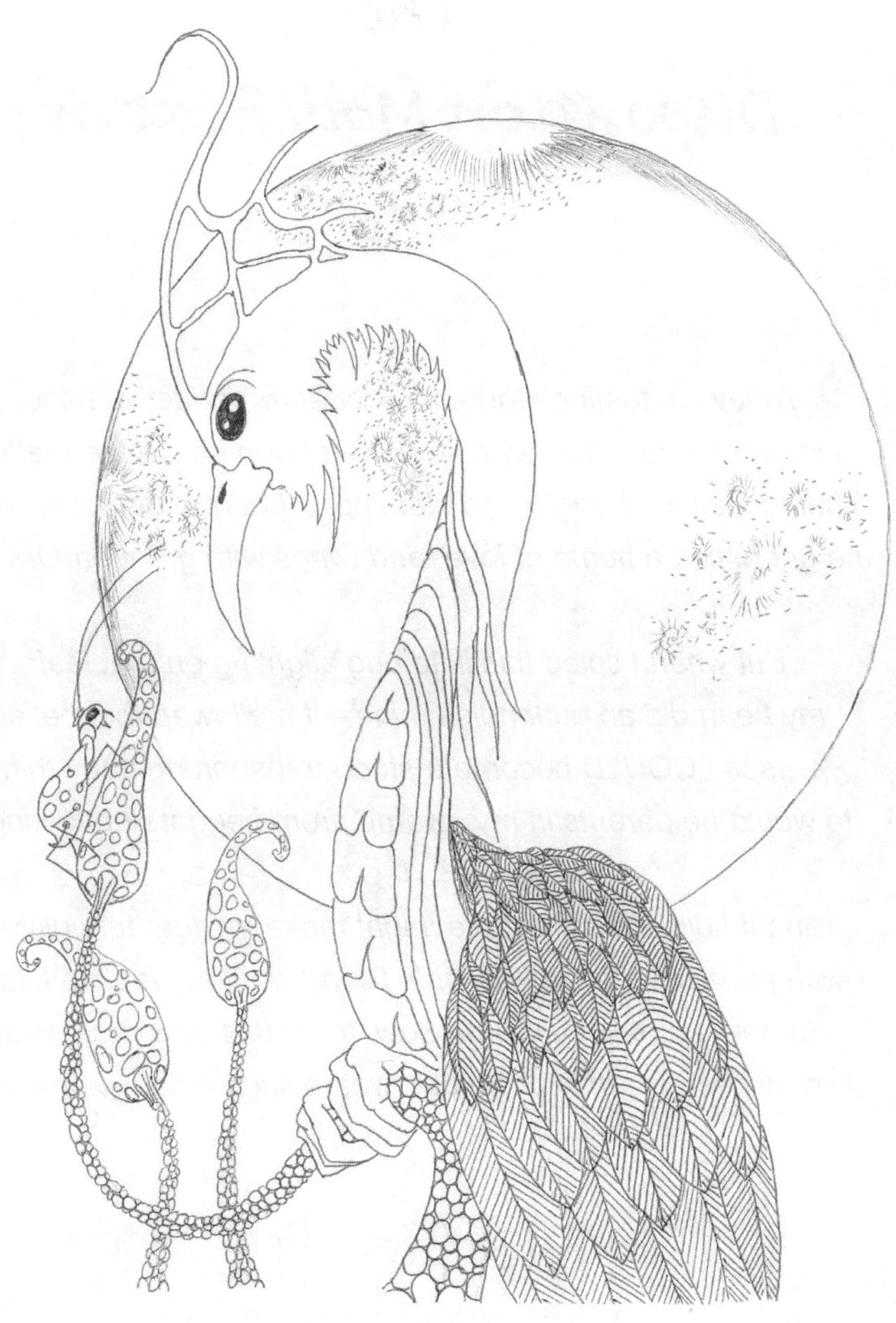

Drawings by Joseph Shivery

The Disposition Modification Bug

Today I'm feeling stork-ish. A brief reproductive fettle.
I know they all think I'm a stork. But I don't have the mettle.
That job takes strength and stamina, a heart of perseverance,
the grit to find a home of love, and wings with great endurance.

But when I spied this little bug alighting on that leaf,
my heart did an outlandish thing—it mellowed that belief!
Perhaps I COULD become a stork, transporting baby things
to would-be parents in my swamp, from beggars up to kings.

And if I did, their gratitude might make my feathers glitter
with pride and colorful delight. Then I wouldn't feel so bitter!
So here I am, I'm airborne now, to try this new profession.
And all because this lonely bug wears such a sad expression!

Stories by Kate (The Quill) Britt

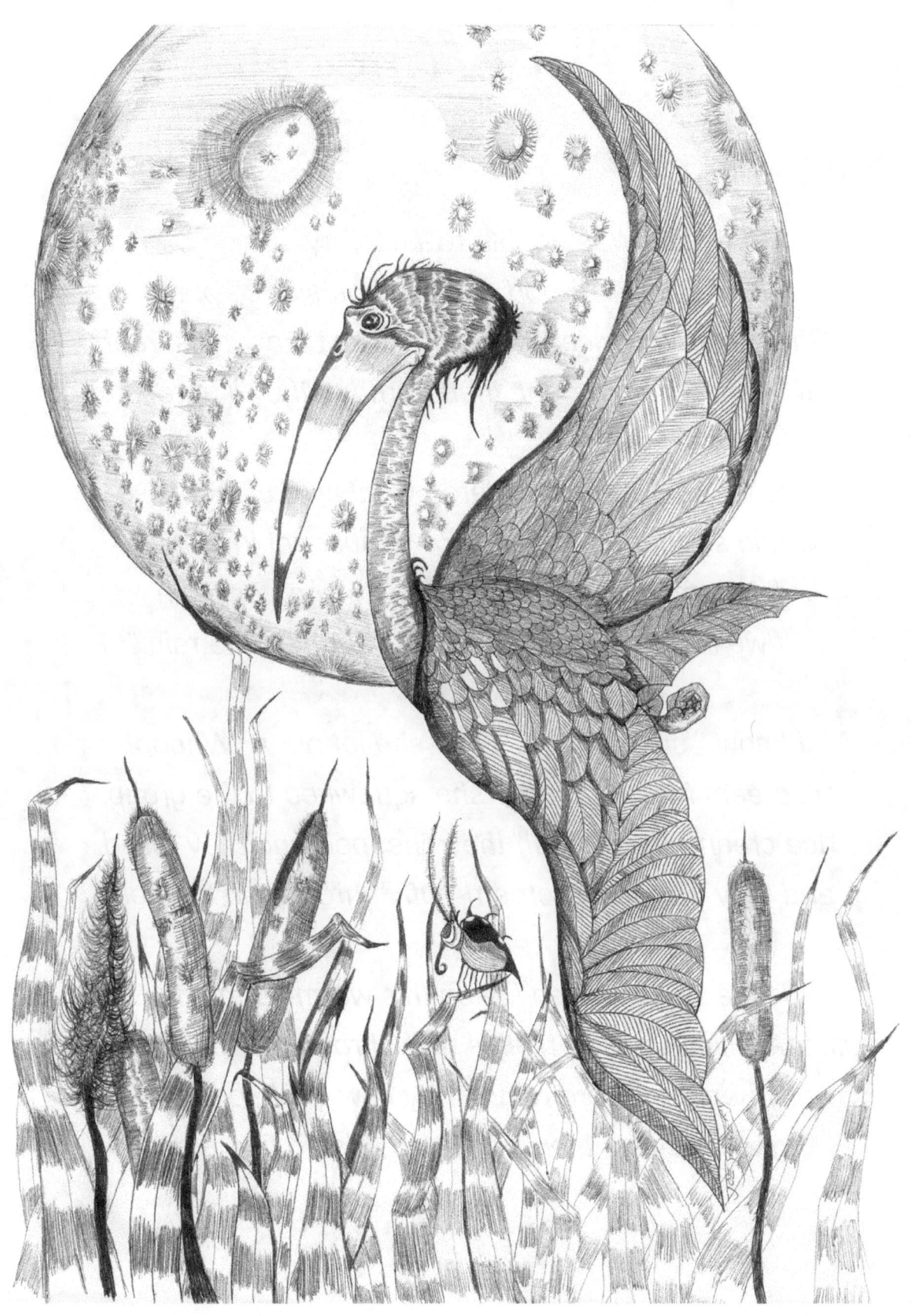

Drawings by Joseph Shivery

Play Time?

The sun was bright, 'twas a very fine day.
Mom-Birdie's brood gathered outside to play.
She became concerned: "They won't leave this tree!
If I make them a deal, then perhaps they'll agree."

She thought and considered what kind of incentive
would send them a-flapping. "I must get inventive!"
"Hmmm," she thought. It was taxing her brain.
"If we linger too long, we'll be caught in the rain."

"I know," she thought. Then she let out a "Whoop!"
"I scream for ice cream," she squawked to the group.
"Ice cream! Ice cream!" they cheeped and they trilled,
and they flew to the cream-puffy shrooms in the field.

There wasn't much ice on this warm sunny day.
Still, they filled up their bellies with shroom curds and whey!
But when they were done, they flew back to this limb.
"I give up," said their mother. "Let's go find a gym!"

Stories by Kate (The Quill) Britt

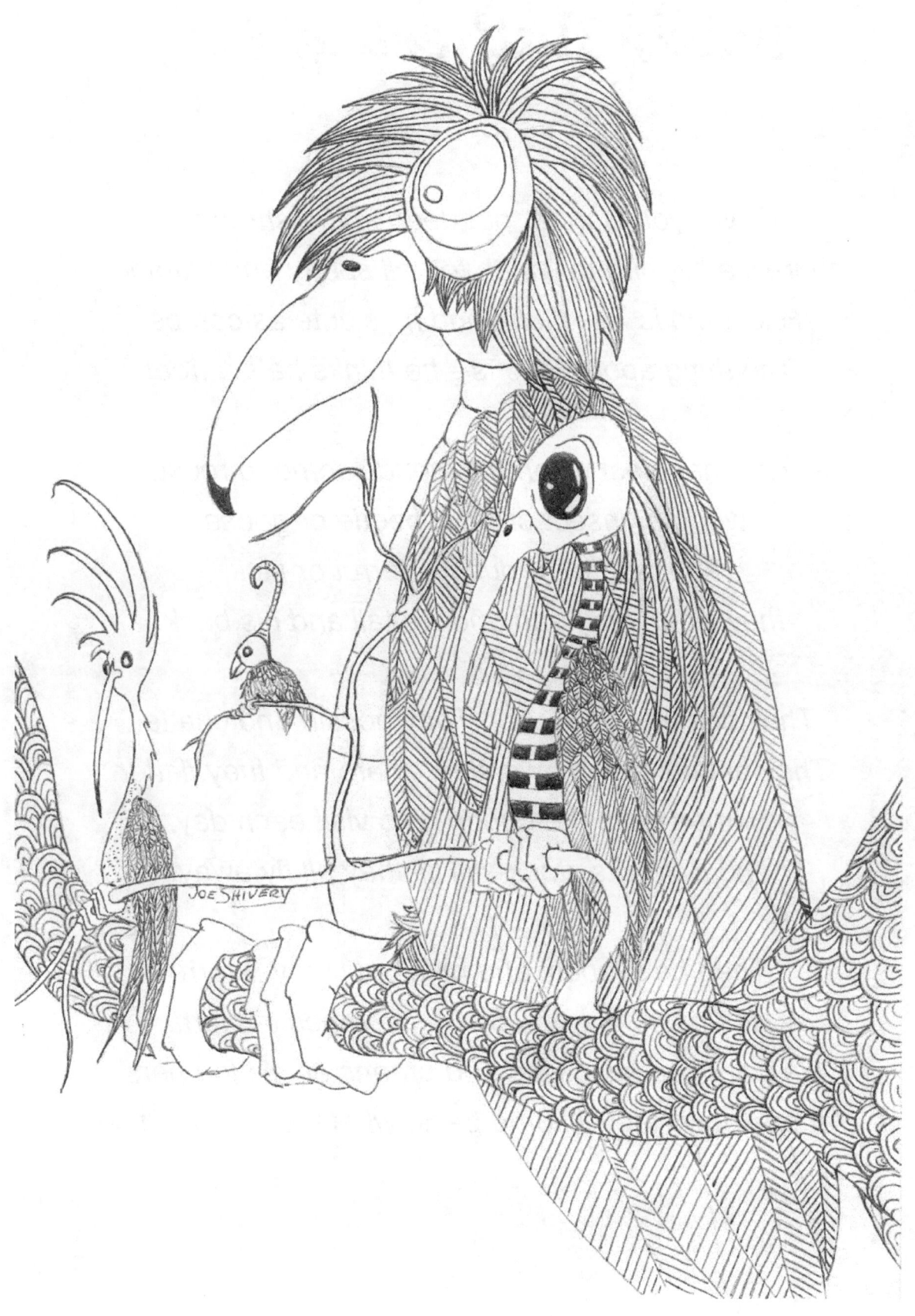

Drawings by Joseph Shivery

Bole's Blathering Bevy

If ever you wander out deep in the shrooms,
there's a big bird to watch for, all spotty and plumed.
His name is The Bole, and he's cute as can be.
The thing about Bole is—he thinks he's a tree!

He's happiest when his friends come to roost,
whether insect or fowl, beetle or goose,
hen, sprite, or ducky, parrot or jack,
they sit on his head and his tail and his back.

They come here to visit. They gossip and chatter.
They babble their news, they share and they flatter.
He has quite the cohort who visit each day,
and Bole sits stock-still 'til they all fly away.

Then he's lonely and blue until they return.
He doesn't say much; he becomes taciturn.
He works on his poses and preens all his feathers.
Yet he knows they'll come back, whatever the weather.

Stories by Kate (The Quill) Britt

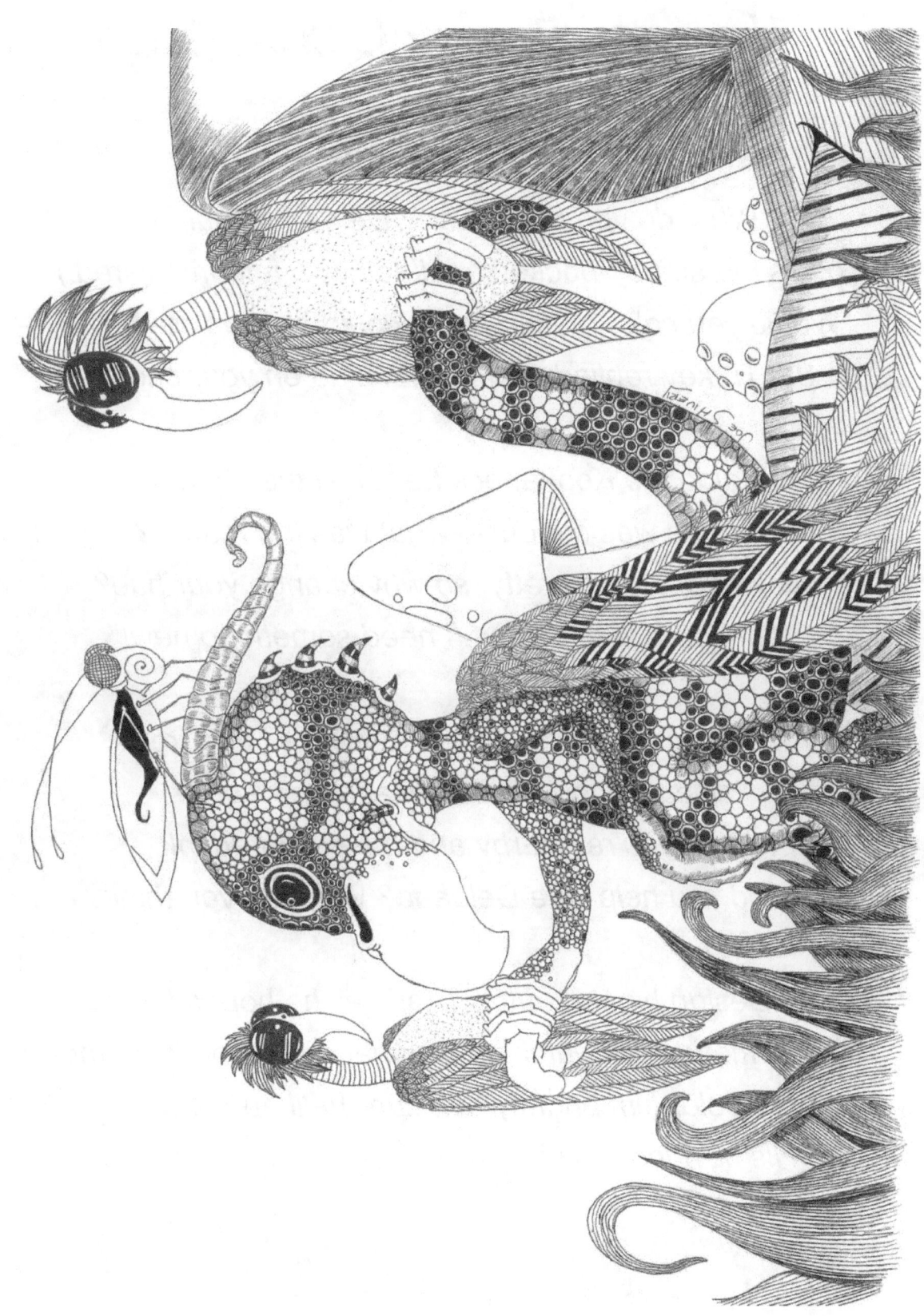

Drawings by Joseph Shivery

How to Bedeck the Bug

"What do you think, Sal?" Delgado inquired.
(He's the stripey-backed snail-tail who felt uninspired.)
"Would you color me pink? Or would blue be the best?"
Sal Turkey replied, "Pink, with blue on your chest!"

Kalda the Kookapeck heard all the chatter.
Feebie was curious—what was the matter?
"Dalgado, you're pretty, so why change your hue?"
"I'm bored with myself. I need something new!"

And this is how four friends who sit in a tree
discuss their affairs, disagree or agree.
So if you're nearby and have colored ink,
Could you help wee Delgado? What do you think?

Design him an outfit. That's all he hopes for!
His bird friends will watch you—what could you want more!
Color him brightly! I'm sure he'll applaud.
His new look will thrill him. Everyone'll be awed!

Stories by Kate (The Quill) Britt

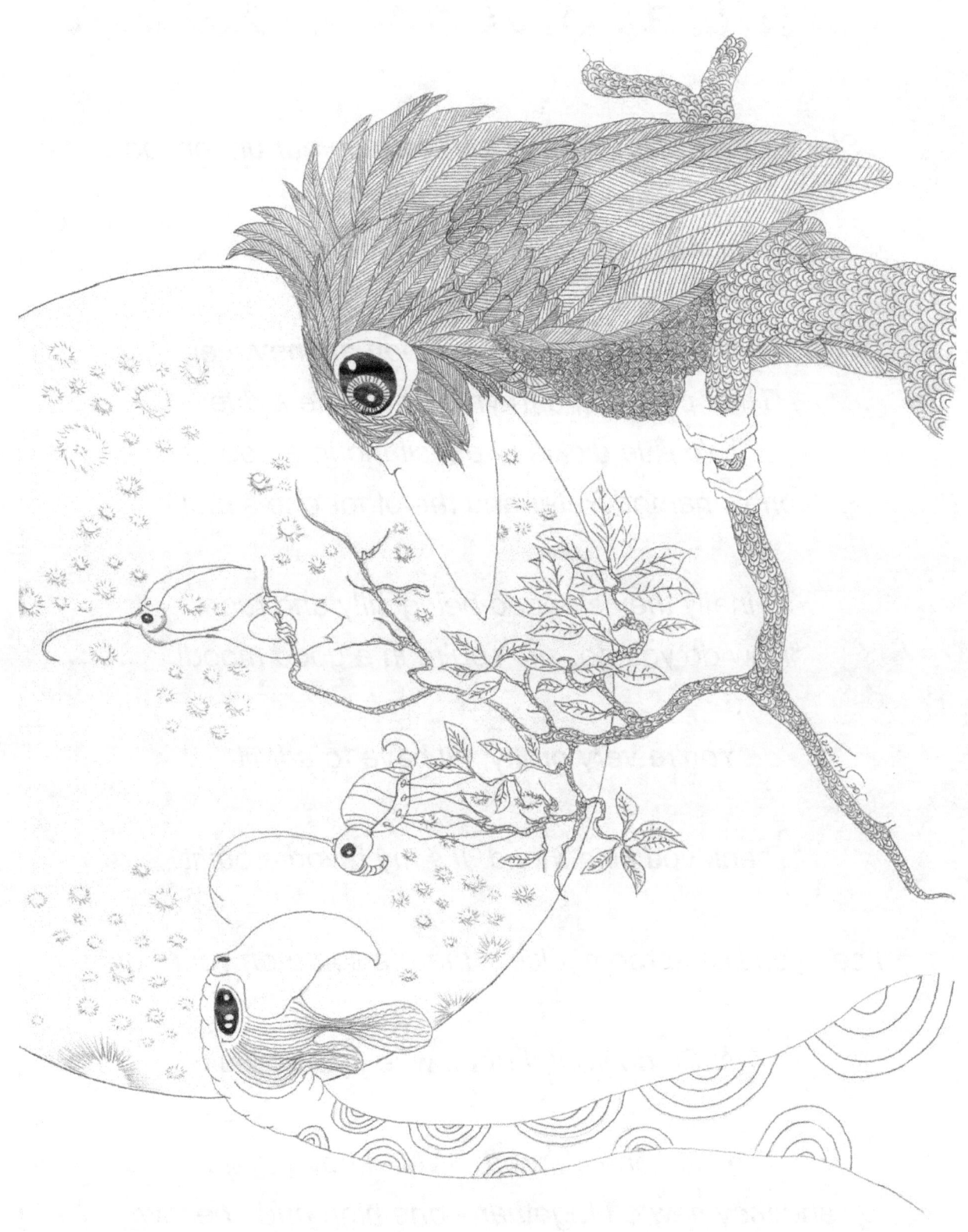

Drawings by Joseph Shivery

Versification Confrontation

"Stare, stare, like a bear. Don't forget your underwear."
"Gawk, gawk, you silly hawk.
Your eyes are round, your face is square."

That's how it started, as soon as they met.
Their chanting of rhymes became a duet.
"Two little dickie birds, sitting in a tree,
one's named Peter and the other one's me!"

Finally they stopped being silly and rude.
"How do you do, sir. You're in a good mood!"

"You're very pretty, I'll have to admit."

"Thank you kind friend. It's my favorite outfit."

"I see you like shroom juice... there's some on your beak!"

"Yes! So do you! It drips when you speak!"

The little one chirped, "Well, I have to go,"
and they flew off together—one high and one low.

Stories by Kate (The Quill) Britt

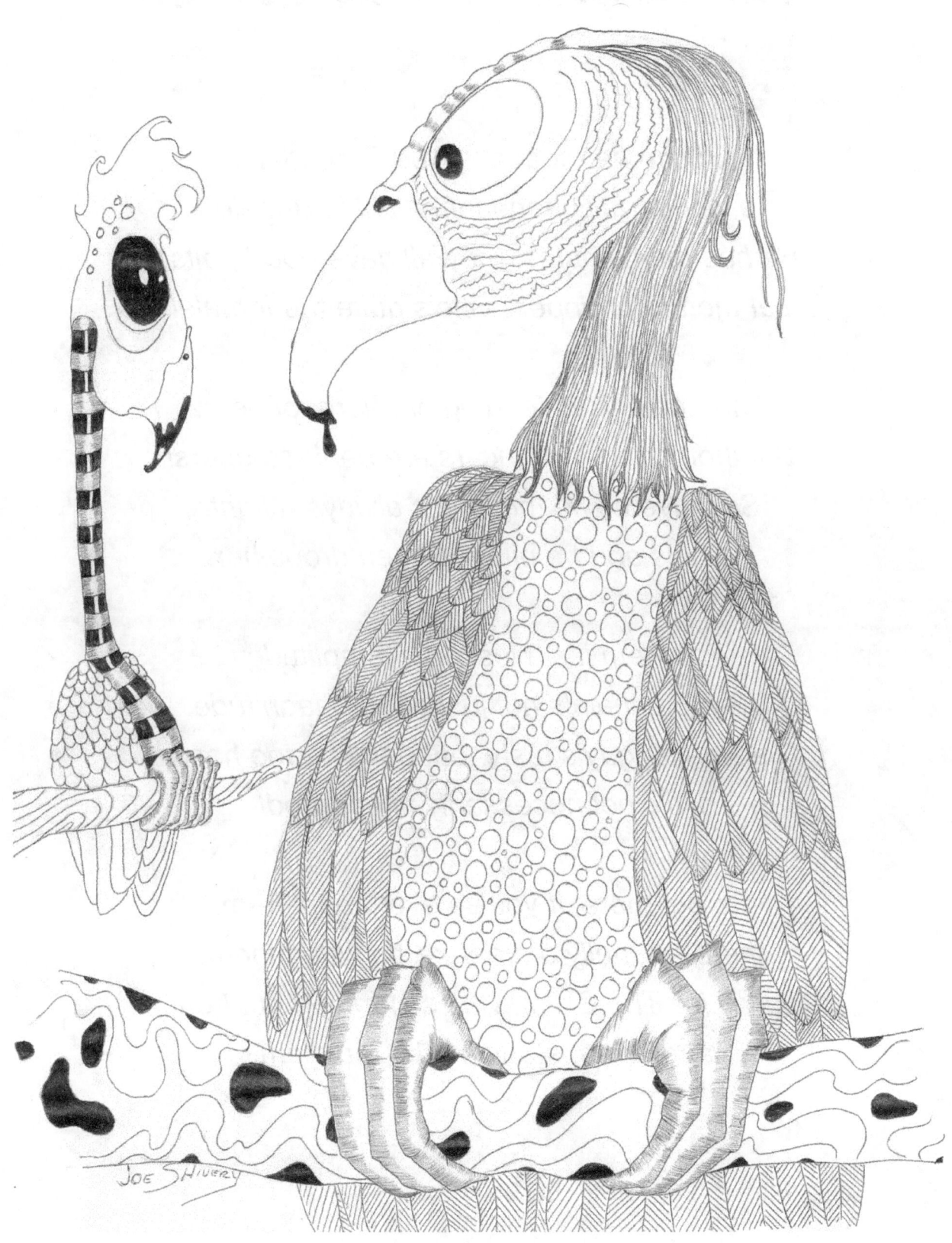
Drawings by Joseph Shivery

Thorndale Wants Lunch

Out in the meadow lived Thorndale,
a wonderfully handsome, tall bird-male.
He has many mates, they all have good traits,
but the thornhopper? She's quite the female!

Thorndale likes feeding on thornhoppers.
But thornhopper's pincers are beak-stoppers!
So strive as he might, it's always a fight.
He nips and he nibbles, then drops her.

For them it's a lesson in amplitude.
The food chain's not just about magnitude.
The smaller guy's tasty, but don't be too hasty!
He's not necessarily finger food!

So out there, if you've ever seen them,
there's usually a creature between them.
Today it's The Grunt, who's standing out front,
a referree, stopping the mayhem.

Stories by Kate (The Quill) Britt

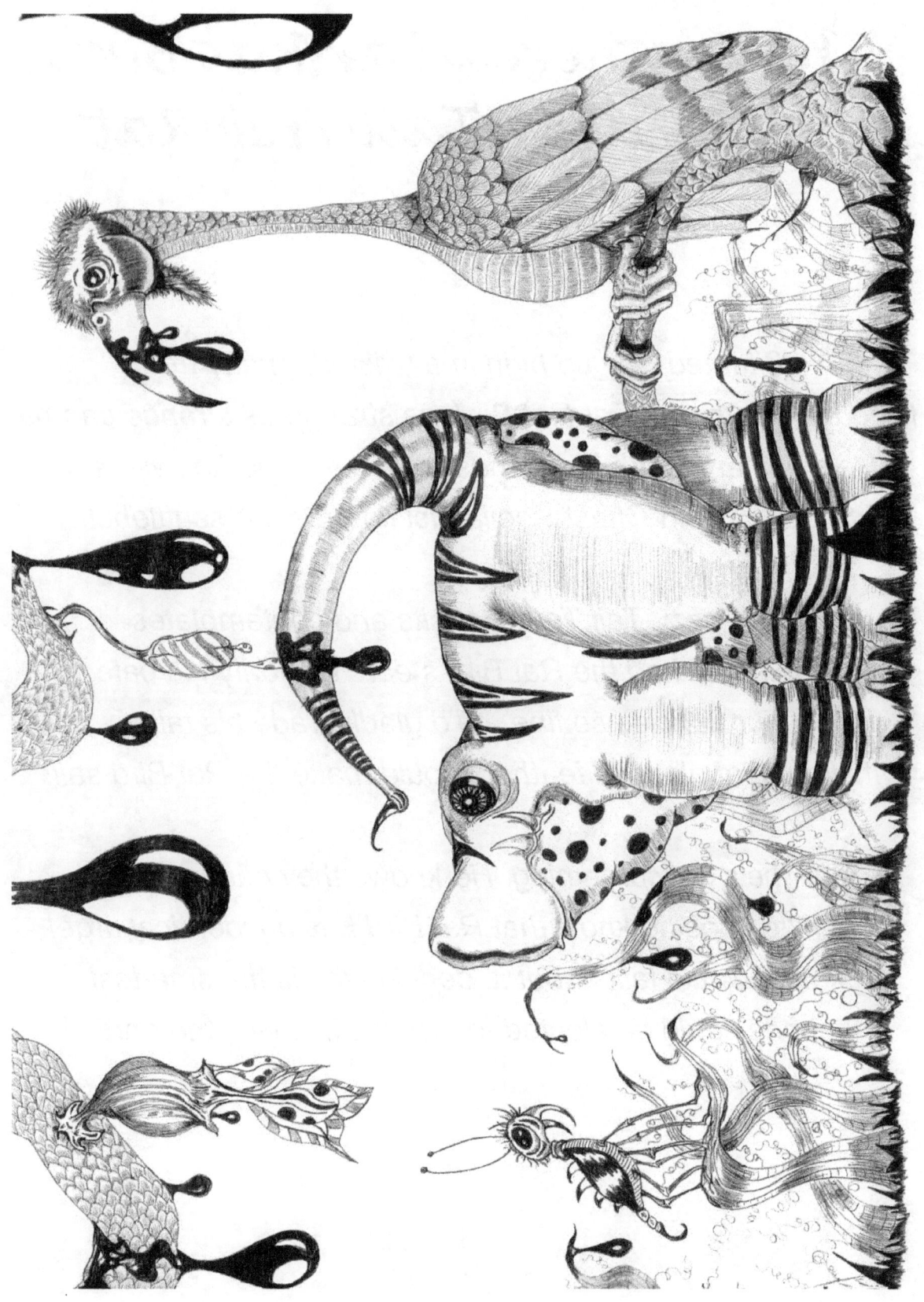

Drawings by Joseph Shivery

The Feathered Ear Rat Bird With Fuzzy-Tail Tree Rat

Situated way up high in a twisted, gnarly tree
lived the Feathered Ear Rat Bird, as strange as strange can be.
He's gathered with his friends, watching who-knows-what.
Snooty Shield-Chest Sheila just ignores the scuttlebutt.

The Fuzzy-Tail Tree Rat sits and contemplates,
wishing he had the Rat Bird's ears to glorify his pate.
For auricles so fine, he'd gladly trade his tail.
Its length of glorious feathers could make the Rat Bird sail!

Alas, he's only dreaming. He knows they cannot merge.
Yet little does he know that Rat Bird has an identical urge!
If they would talk about it, decide who is the smartest,
that one could be elected to discuss this with their artist!

Stories by Kate (The Quill) Britt

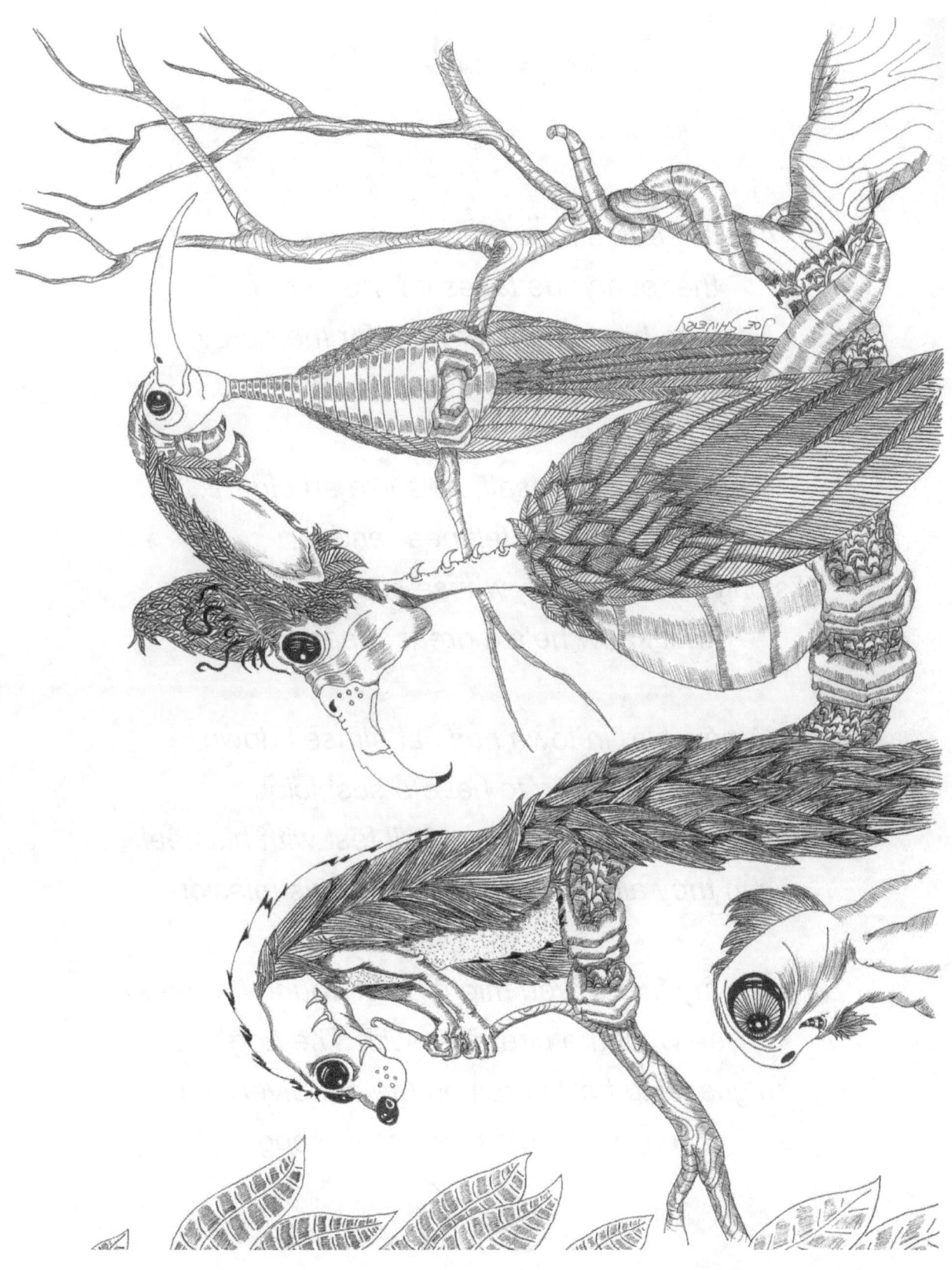

Drawings by Joseph Shivery

The Old Log

Ancient and strong, it's been there so long
that everyone takes it for granted.
They gather to play, or hunt for their prey,
with no thought of when it was planted.

The Old Log himself, he's like an old Elf:
his magic is felt near and far.
It's only the shrooms, whose sap he consumes,
that know he's a great superstar.

A new bird in town has sat himself down.
He's starting to have a suspicion
that The Old Log's unique. He'll test with his beak
when they all leave. He'll make it his mission.

So later, my friend, you might peek 'round the bend,
see what the bird does with The Log.
I'm guessing he'll perch on the old Siverbirch,
to enjoy this old friend in the bog.

Stories by Kate (The Quill) Britt

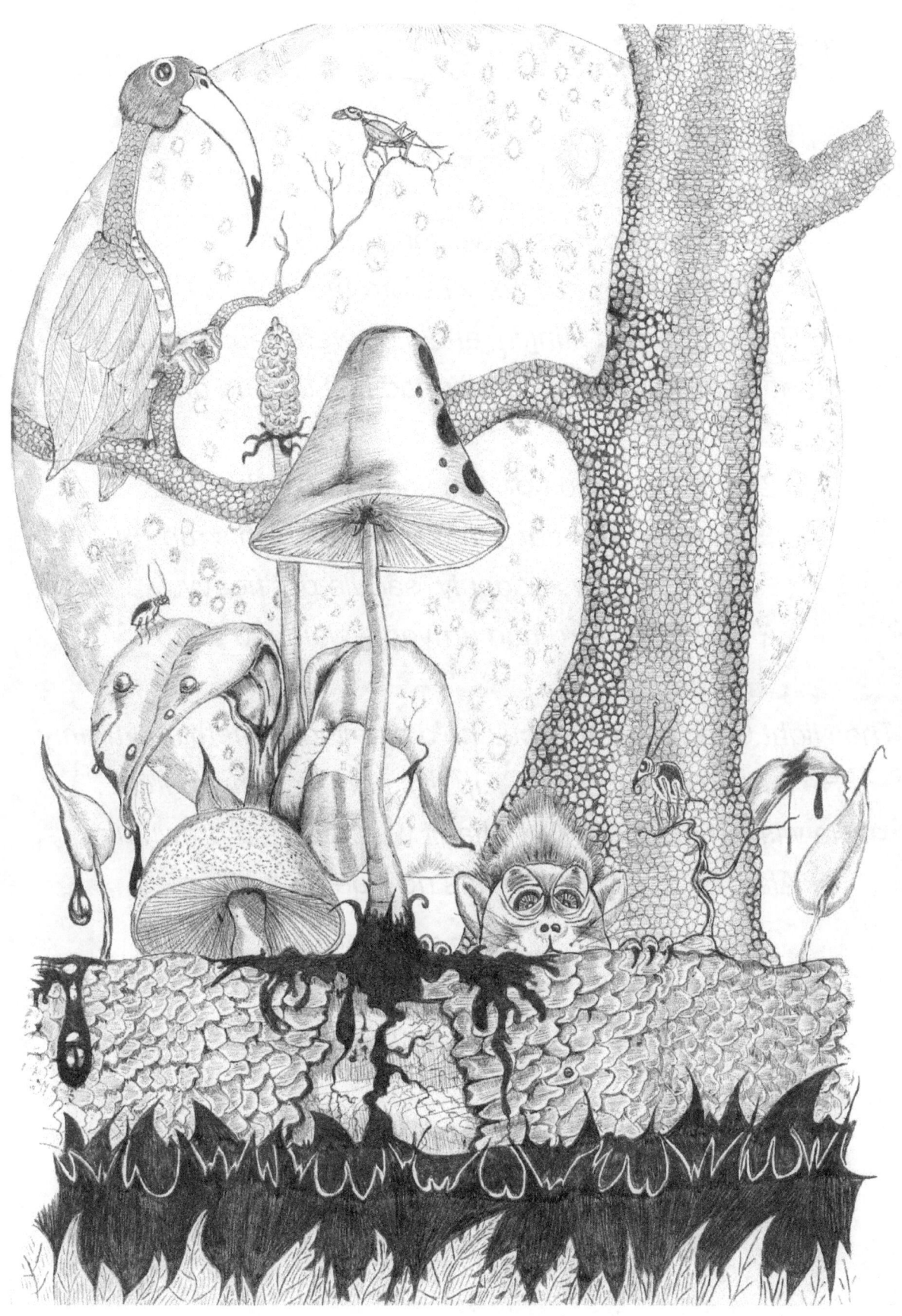

Drawings by Joseph Shivery

The Night Cap Saddle Bird

Sally Johansen McJohnson O'Hara
was feeding her pony before the long ride.
The food was a stinkin' and flies were a-buzzin'—
it smelled like a neighbor had just up and died.

Zee Pony cared not. His snout couldn't smell.
He'd hurry and eat. He was keen for this run.
But then very suddenly, saddle got heavy.
A big friggin' bird had arrived—weighed a ton!

The Night Cap had come 'cuz he'd smelled something yummy.
He landed and sniffed. "Yup, it's right near my perch..."
He wished he could see what it was that had drawn him.
Alas, he's not bright—has no clue he's reversed!

How could Zee run now? His Sally was waiting!
"What can I do with a bird who's senile?"

And that's how they all came to be in this stalemate.
You might as well color. We'll be here a while!

Stories by Kate (The Quill) Britt

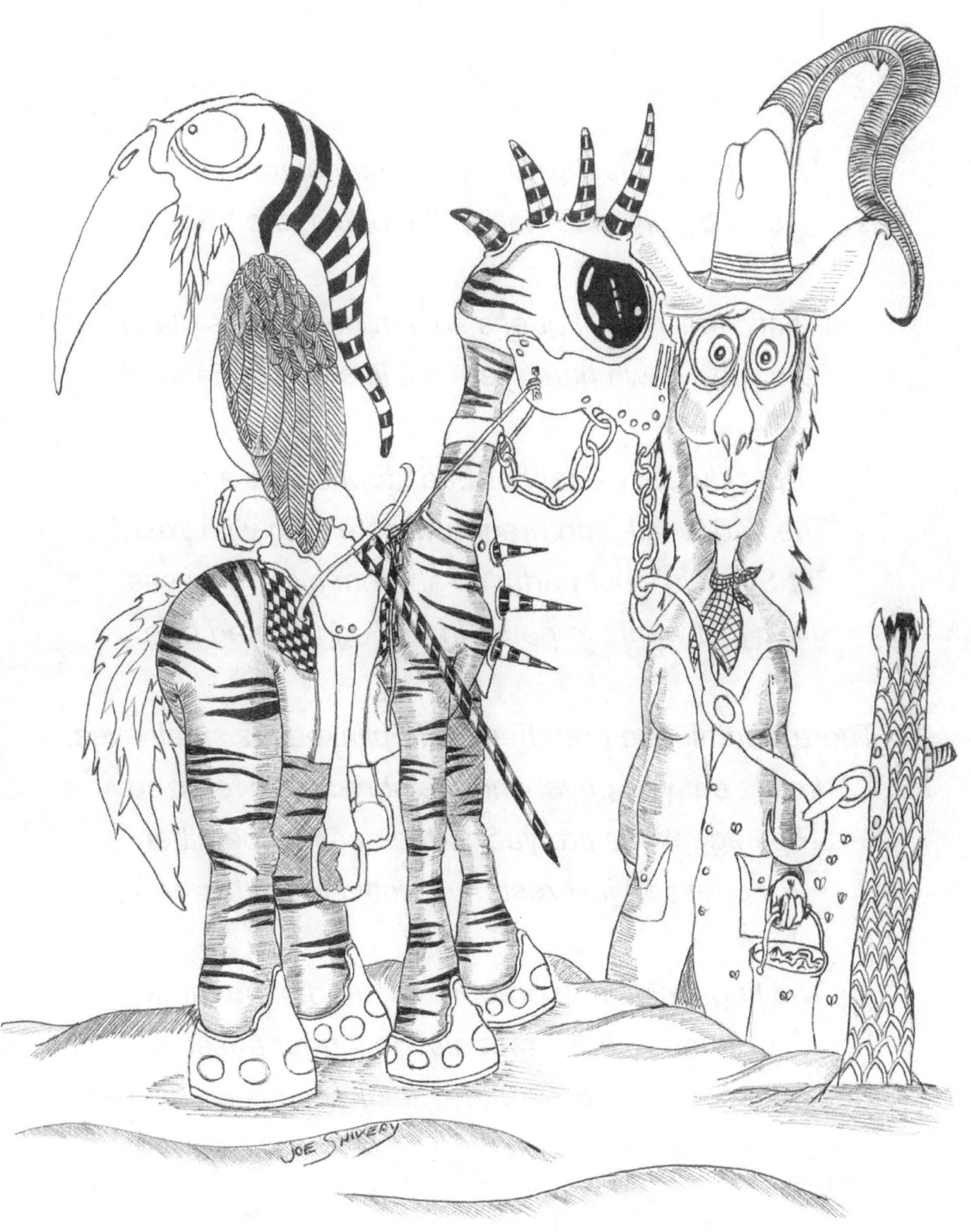

Drawings by Joseph Shivery

The Speckle Belly Grabber

"An industrious day in the shroom patch, I see,"
said Snaily McStripe to the bird in the tree.

"What's that? Oh, I guess so. I'm new to this place.
"Crowded down here, yes, but lots of air space..."

Speckle Belly Grabber had stopped for a rest.
The bug, snail, and dragon were eating with zest.
But Speckle's not partial to shroom juice, you see.
He's just wants to perch in this eggplanted tree.

"There's nothing to grab here." He blinked his small eyes.
"I can't eat you guys, and the shroom's oversized.
Ripe eggplants are yucky, their sap is too bitter.
I guess I'll just rest here until I feel fitter."

The bug, snail, and dragon, assured of no threat,
went on with their meals, no longer upset.
Aha, thought the Grabber, they think there's no danger.
I could grab one and eat it! DO NOT trust a stranger!

Stories by Kate (The Quill) Britt

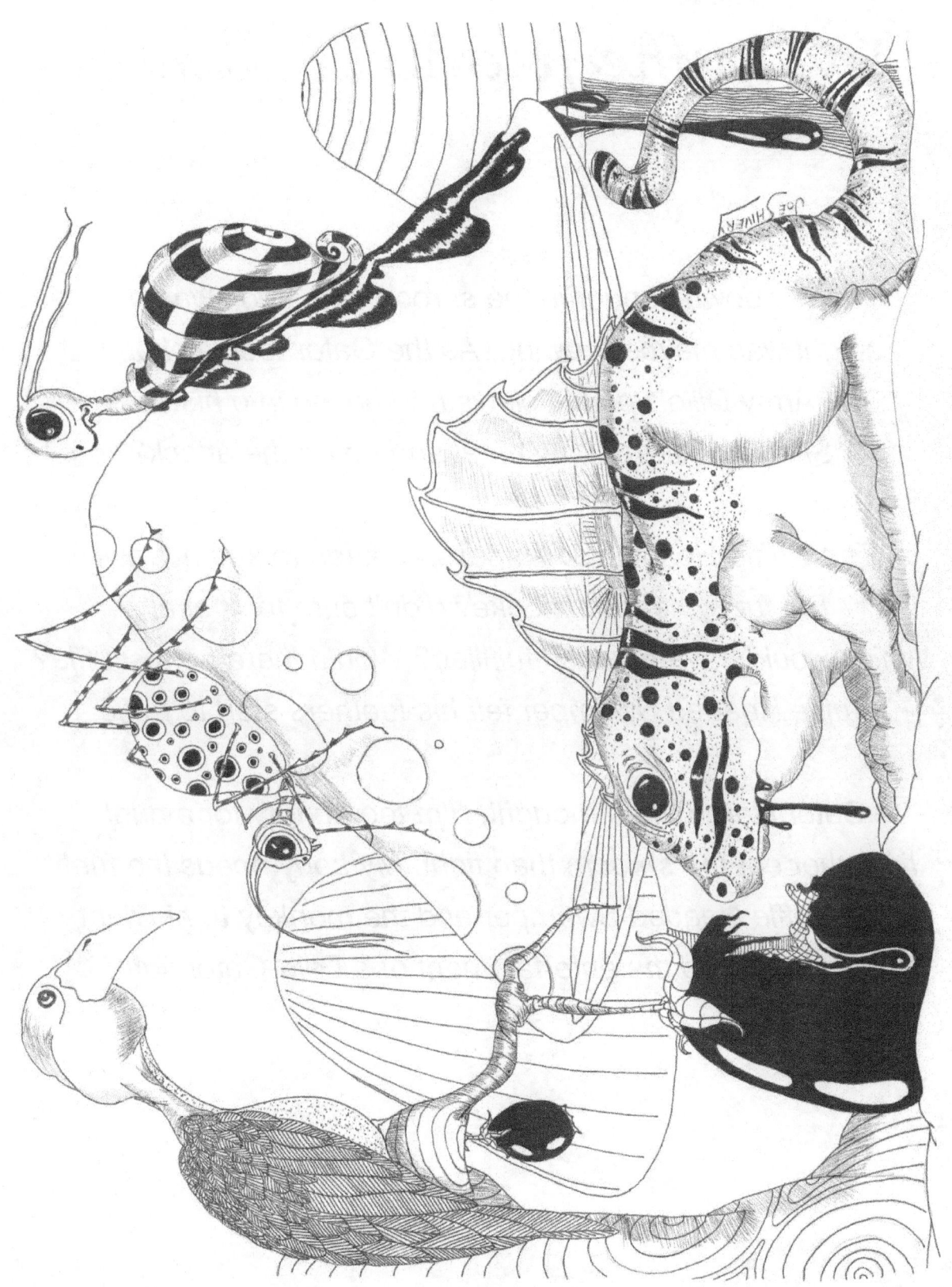

Drawings by Joseph Shivery

The Ruffle Headed Swamper

Way down yonder in the shroom-infested swamp
a fight was maybe brewing. As the Gator took a chomp,
the Army Dillo's pointy claws had poked into his back.
"Should I interrupt my meal and go on the attack?"

The Ruffle Headed Swamper was keen to see a brawl.
But fuzzy headed monkey didn't care for it at all.
Which would have his wish fulfilled? Would there be a scuffle?
Ruffle Headed Swamper felt his feathers start to ruffle.

Gator stared, then thought, "I'm too hungry for a duel.
I'd rather eat the shroom than fight. My body needs the fuel."
So Ruffle Headed Swamper and the monkey to his right
were denied the entertainment of a Dillo-Gator fight.

Stories by Kate (The Quill) Britt

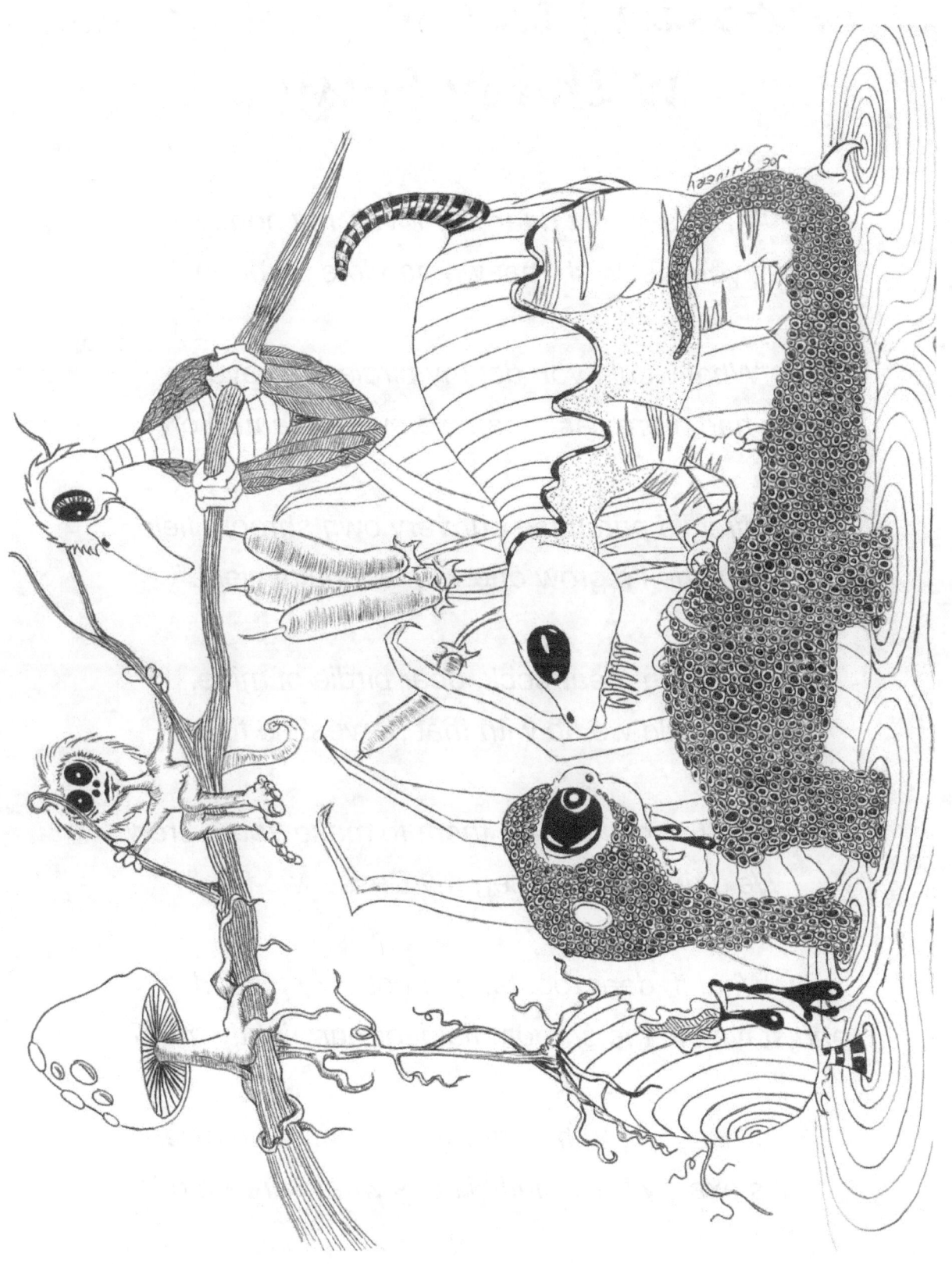

Drawings by Joseph Shivery

Overlooking the Shroom Fields With My Bessy

"Ah, Bessy, my dear, my lover, my honey,
don't you just wish that we had lots of money?"

"What would you do, my birdie, my love,
if we had more cash than we ever dreamed of?"

"Well, first I'd purchase our very own shroom field,
or maybe I'd grow one with bountiful yield."

"And then, dear cock, dear birdie of mine,
what would we do with that harvest so fine?"

"I'd squish them and juice them to make you a brew!"
We'd drink it together, my Bessy, we two."

"What if, dear rooster, we got very pissed,
and stayed in the shroom field for our nightly tryst?"

"Well Bessy, my heartthrob, my only true love,
that's exactly the point! That's what I dream of!"

Stories by Kate (The Quill) Britt

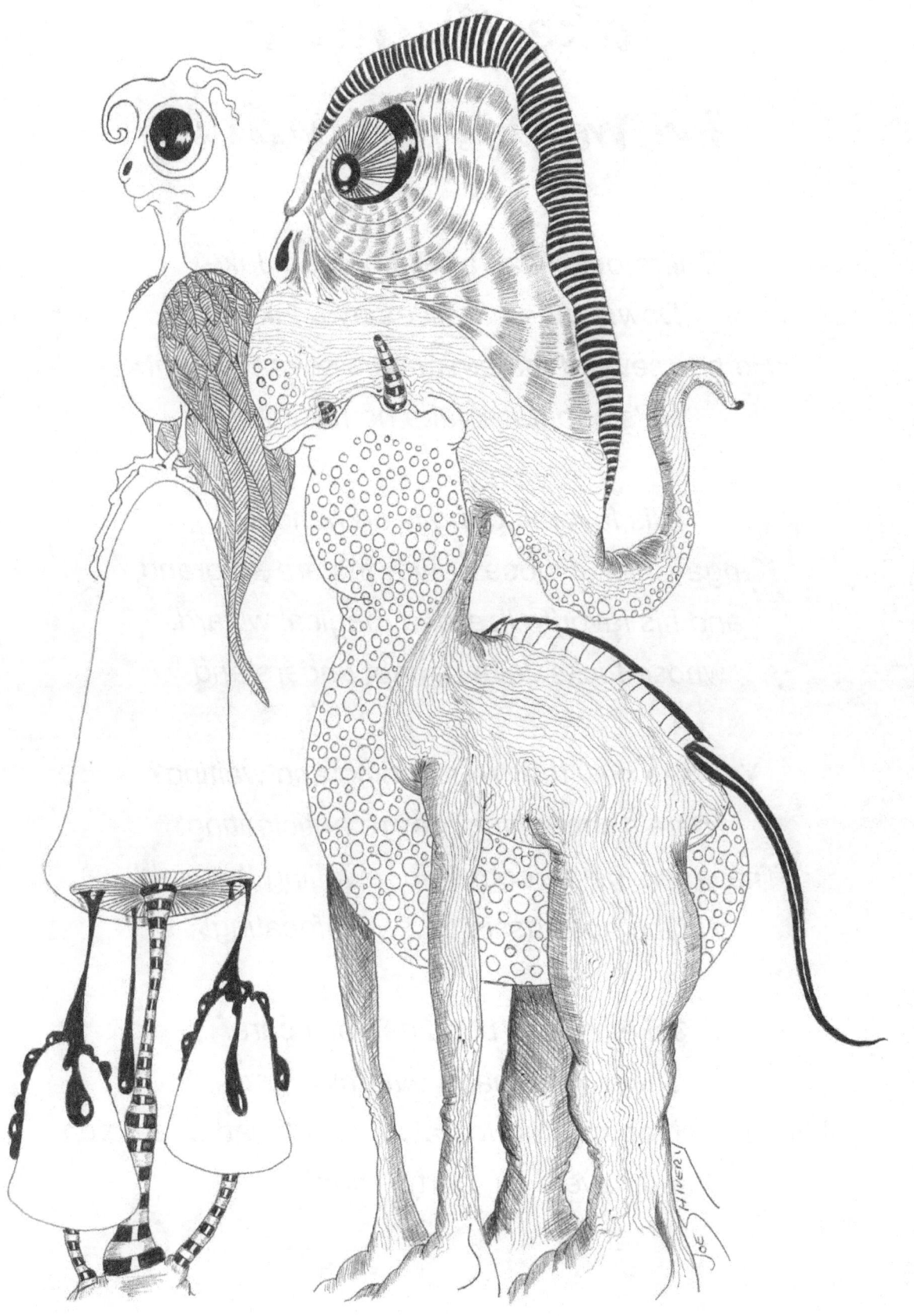

Drawings by Joseph Shivery

Jake Thunder From Down Under

There once was a fella named Jake.
Down under, he lives by a lake.
He has several mates, maybe seventy eight.
He's popular, make no mistake!

His favorite gang is on hand....
Kanga-Chick, whose new twins are so grand,
and his favorite lizard, a magical wizard,
whose tricks Jake cannot understand.

You see how they're standing and waiting?
There's something they're anticipating.
They're in the shroom field, awaiting the yield,
in the hot Aussie air..... suffocating!

Jake and his buddies don't care.
They like to hang out anywhere.
When the shrooms start to hatch, they'll gather a batch
and have a big party—right there!

Stories by Kate (The Quill) Britt

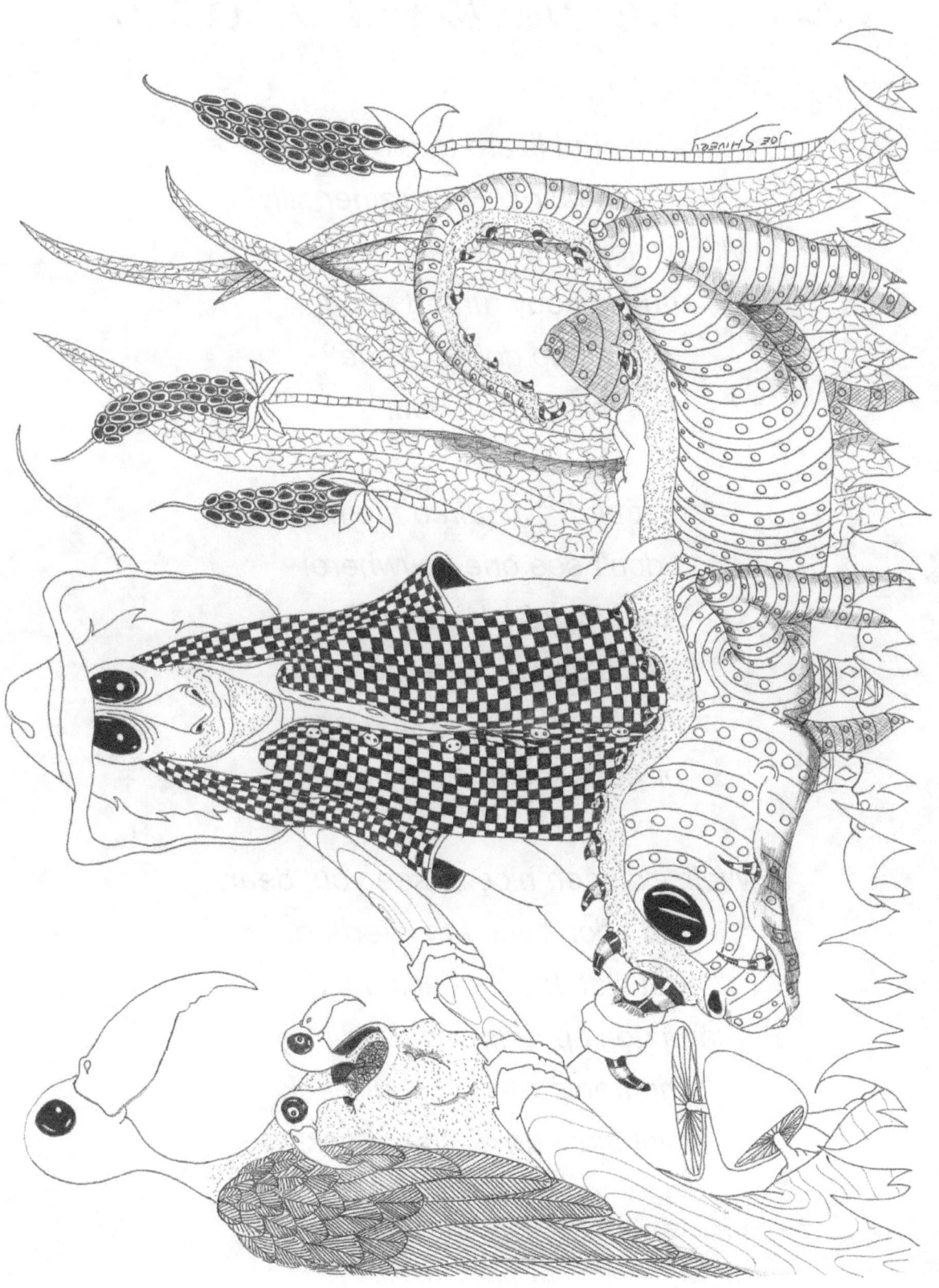

Drawings by Joseph Shivery

The Long Neck Freeloader

Said the lizard to the filly,
"Who's the bird? He's rather silly!
With his long neck stretched way out
and his body turned about...
how's he going to ride?
He'll fall right off your side!"

"What bird?" inquired the mare.
I don't see one anywhere!
And I didn't plan on riding.
I was standing here deciding
if I should have a little nap
or go buy a baseball cap."

"Well, it's been nice to see you, dear,
and I don't want to interfere.
But watch your back, I say,
and don't put up with fowl play.
The freeloader on your back
might just go on the attack!"

Stories by Kate (The Quill) Britt

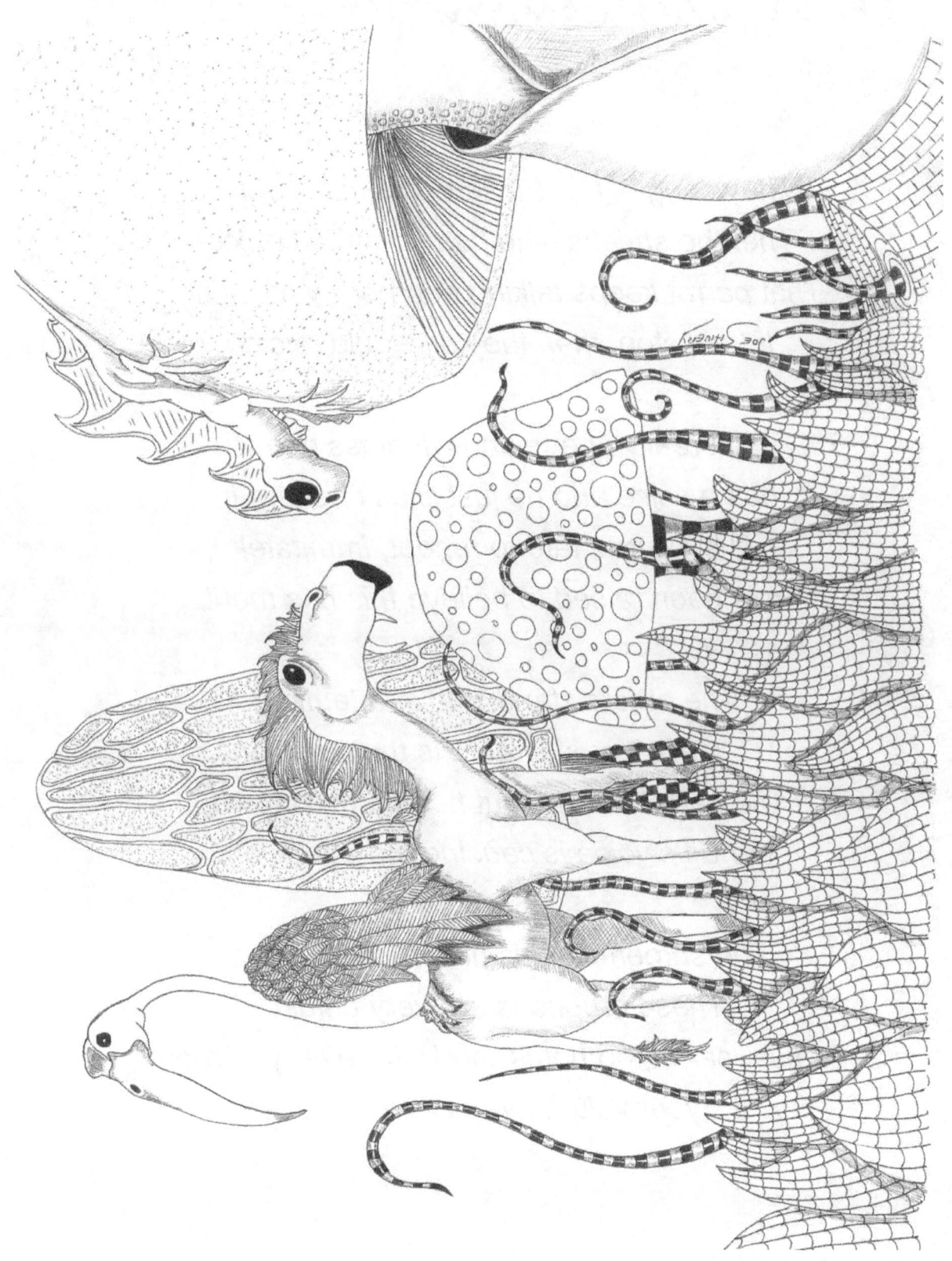

Drawings by Joseph Shivery

The Wingless Shroom Parrot

They cringe. The Elf screams in full voice.
Then he shrieks—he has no other choice!
That parrot keeps talking and noisily mocking.
If he'd stop, then they all would rejoice.

But really, the young wingless parrot
has a voice and he just likes to share it.
It is his true fate to repeat, immitate!
He's been raised to believe this has merit.

The others stand still, at attention.
To leave? or stay put? is the question.
The parrot is loud, but here in this crowd,
the Elf's voice is causing more tension.

The shroom field is usually so hushed.
These eruptions are very unjust.
Please, parrot, go home, and wherever you roam,
it's your volume you need to adjust.

Stories by Kate (The Quill) Britt

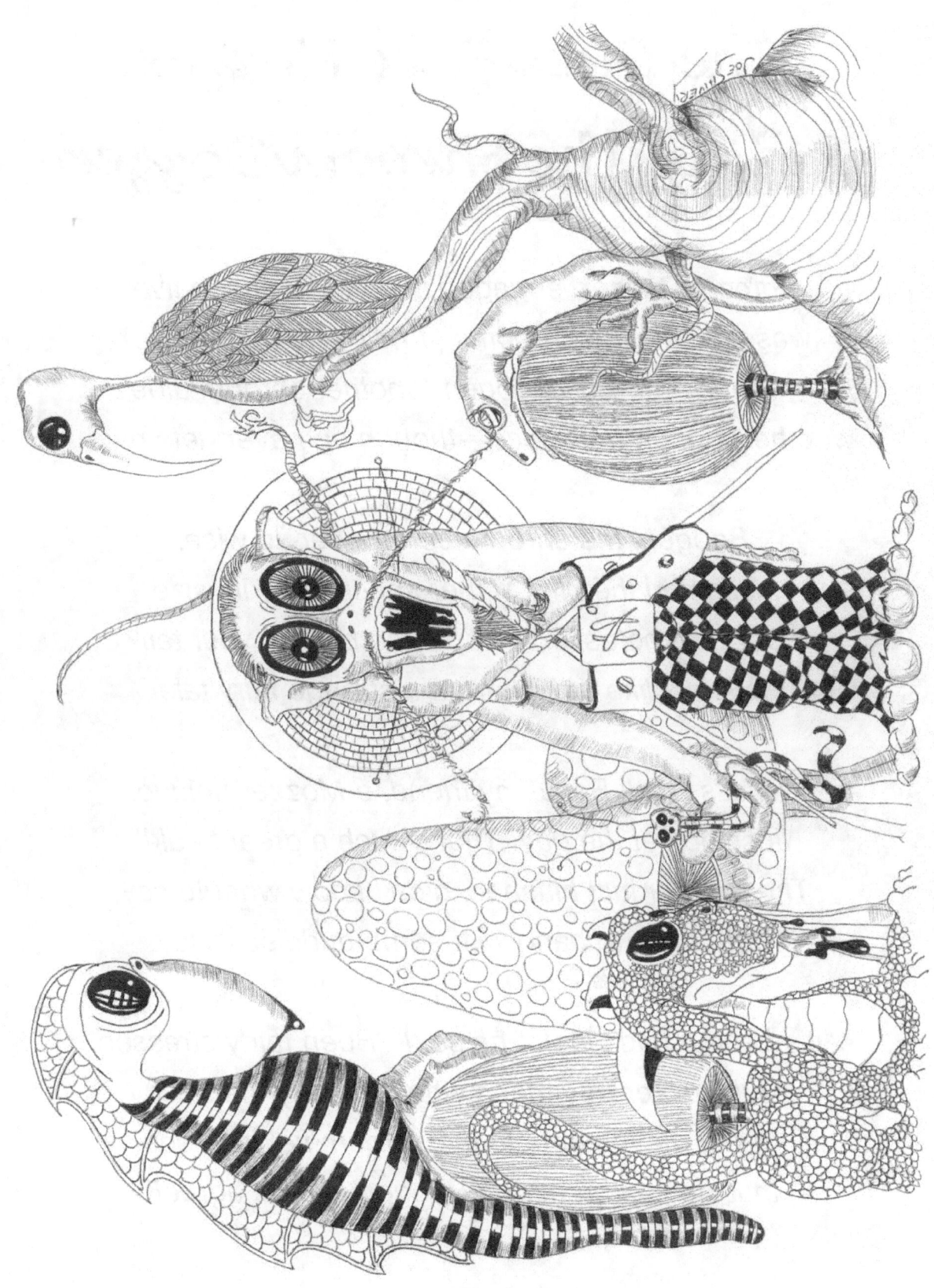

Drawings by Joseph Shivery

The Duck Face Mozzer Riding The Shroom Dozzer

Shroom Dozzer, engaged in today's nine to five,
was dozzing the shrooms (it helps them to thrive).
Along came Bug Boogen (another shroom aide
who helps drain their juice—though he never gets paid).

Boogen, the shroom borer, ever so wise,
inspected the bird, rather shocked by its size.
"Dozzer," he asked, "who's the bird on your tail?
He looks like a duck from a strange fairy tale!"

"That's Duck Face, my friend, a Mozzer unique.
Just look at the guy! That's such a great beak!"
The Mozzer just blushed, didn't know what to say,
just happy to hang with some buddies today.

"It's been a bad week," he said. "Been fairly stressed.
But Dozzer (my friend who is simply the best)
asked me to come to the shroom fields to see
that life can be good." Boogen said, "I agree!"

Stories by Kate (The Quill) Britt

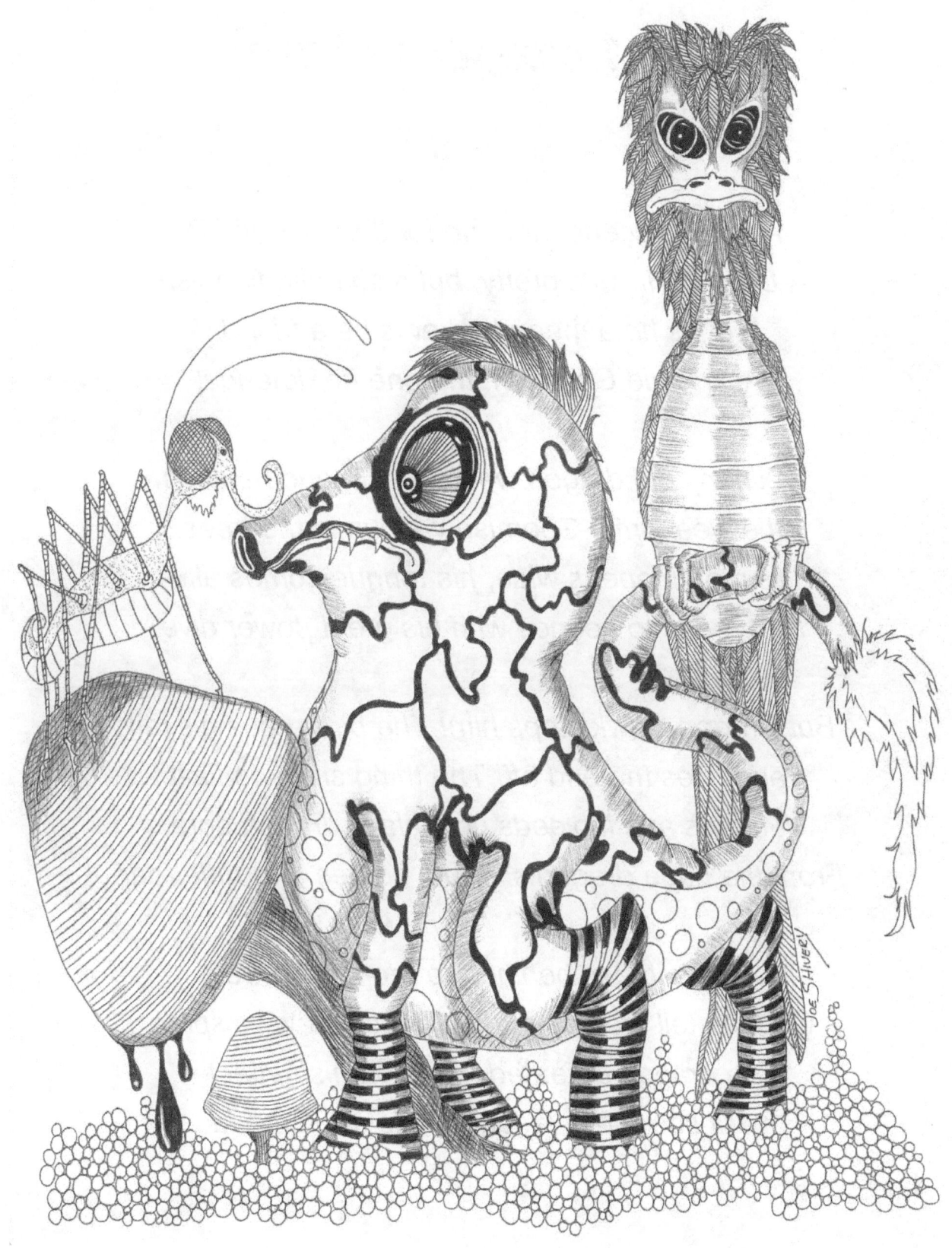

Drawings by Joseph Shivery

The Dragon Hawk

A terrible scene, not one for the squeamish.
A Dragon Hawk's pretty, but also quite fiendish.
Yet, is he a mean bird or is he a friend?
Ask Timid Goomish, the one he defends!

A snarly old dragon wants lunch, and he sees
the wee Timid Goomish way up in the trees.
His mouth opens wide, his tongue comes alive
he's ready to pounce with his great power dive.

But Dragon Hawk stops him! The bird grabs his tail,
and bites the end off! The thing starts to flail!
It spurts and it bleeds ugly black dragon gore.
From the huge dragon's mouth comes a terrible roar.

The witness behind the broken old tree
will long tell the tale of the Dragon Hawk's spree.
The dragon defeated, the Goomish intact—
it will soon be a legend, believed to be fact.

Stories by Kate (The Quill) Britt

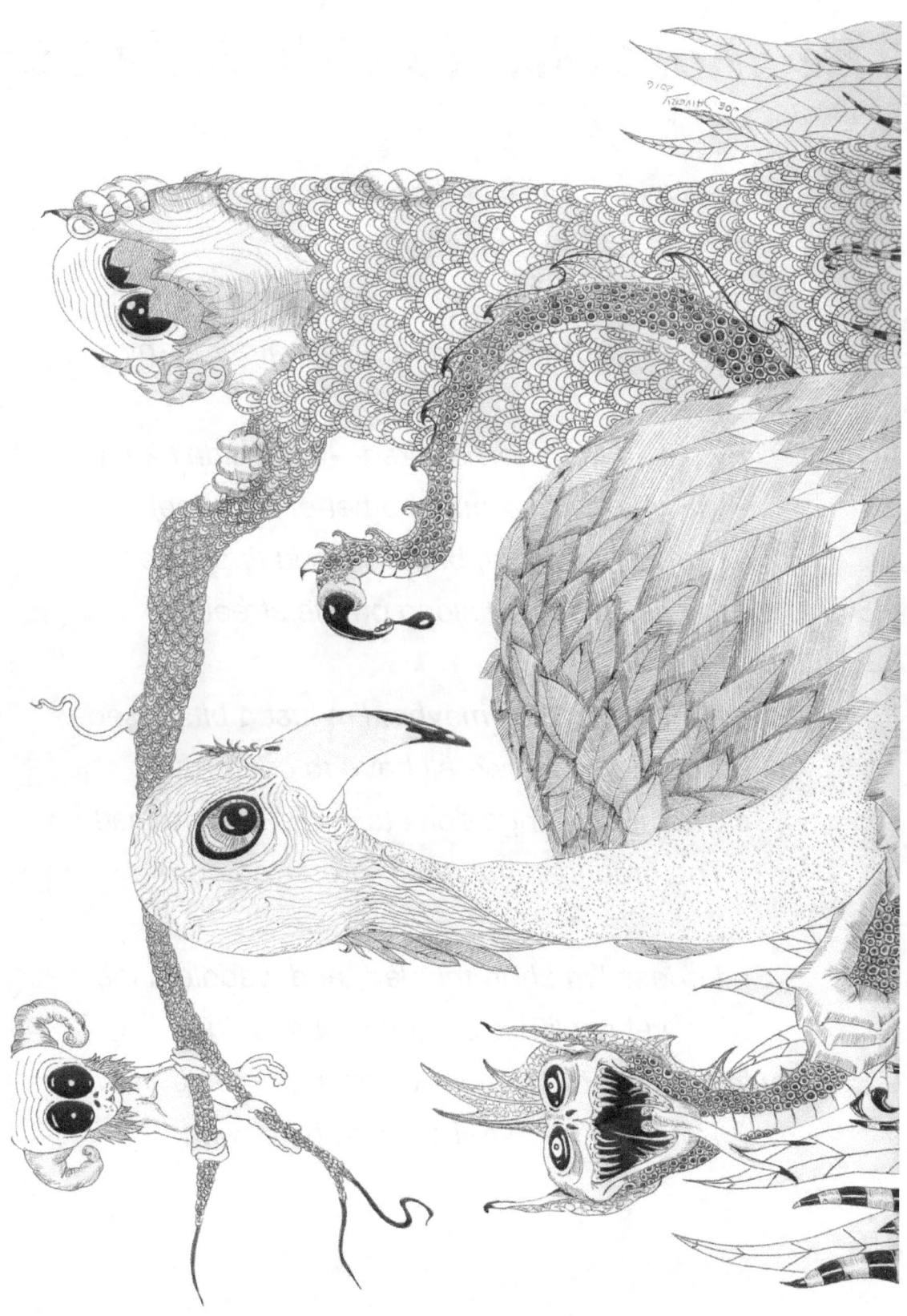

Drawings by Joseph Shivery

The Short Minded Waddle Bird

When I was little I preferred to walk.
The parents, they wished I would fly.
When I walked, I'd waddle away from the flock
while my siblings would practice their fly-by.

They called me short sighted—I just didn't know
why my wings would be better than feet.
I knew I could fly, but preferred tippy-toe
as I waddled along on the street.

Narrow minded? Well maybe. I'm just a bit biased—
don't believe we all have to conform!
So what if my wings don't take me the highest!
The ground is my much-preferred norm.

So I guess I'm short minded, and waddle a lot,
yet my life is a wonderous thing.
My friends are the ground-dwellers, not astronauts!
When I need to I still can take wing.

Stories by Kate (The Quill) Britt

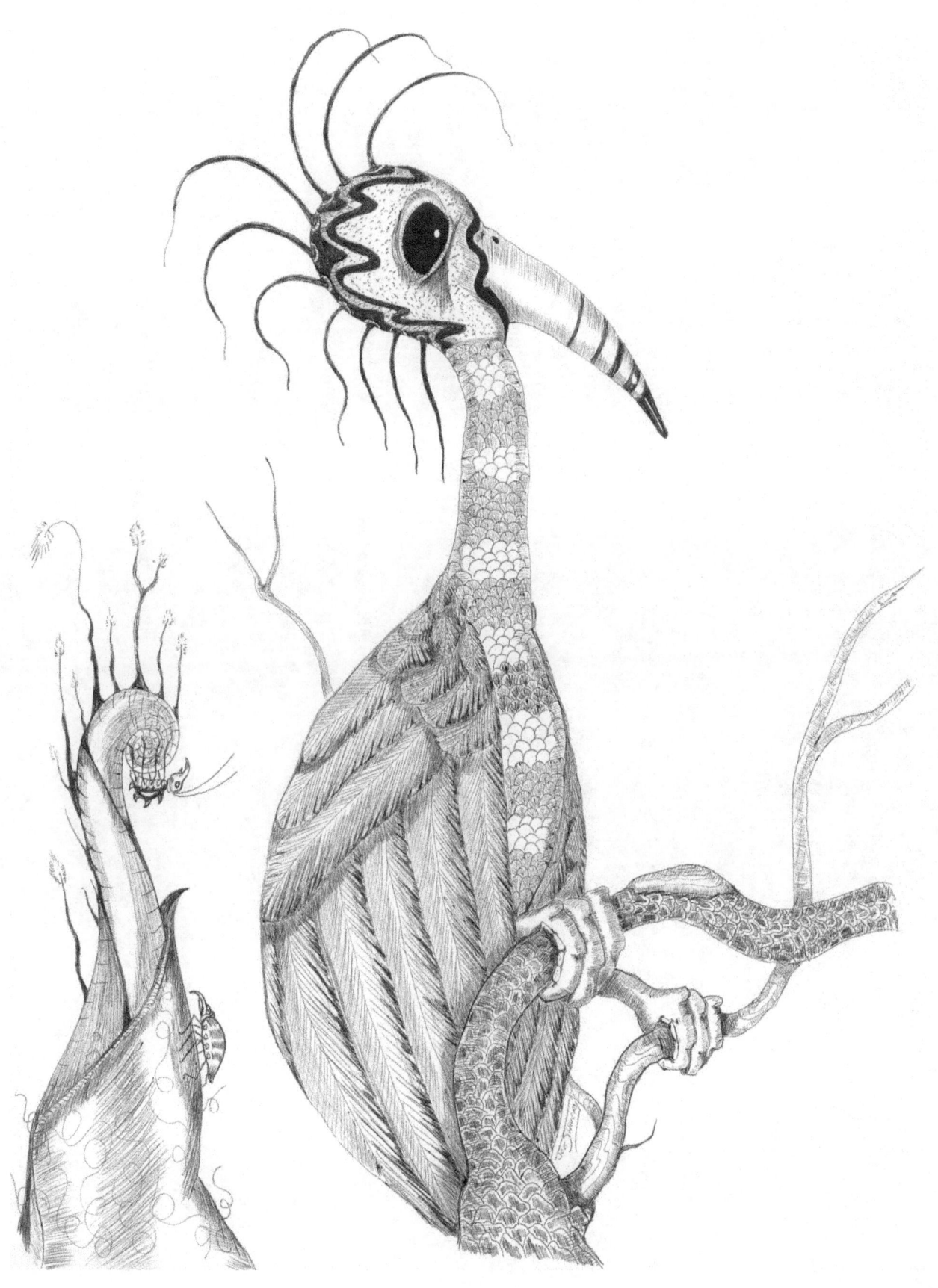

Drawings by Joseph Shivery

www.ingramcontent.com/pod-product-compliance
Lightning Source LLC
Chambersburg PA
CBHW080621190526
45169CB00009B/3255